Images of America
Homestead and the Steel Valley

On the cover: For many years, Nick Sayko was the United States Steel Homestead Works photographer. During that time he was responsible for not only photographing all aspects of the plant operations, he was also tasked with the design and layout for all the mill's safety posters, artwork, and much of the outside advertising. Always seen with his camera in hand, Sayko is pictured on the lower left of this photograph. (Ginny Buday.)

IMAGES of America

HOMESTEAD AND THE STEEL VALLEY

Daniel J. Burns
for the Carnegie Library of Homestead

ARCADIA
PUBLISHING

Copyright © 2007 by Daniel J. Burns for the Carnegie Library of Homestead
ISBN 978-0-7385-5487-7

Published by Arcadia Publishing
Charleston SC, Chicago IL, Portsmouth NH, San Francisco CA

Printed in the United States of America

Library of Congress Catalog Card Number: 2007926841

For all general information contact Arcadia Publishing at:
Telephone 843-853-2070
Fax 843-853-0044
E-mail sales@arcadiapublishing.com
For customer service and orders:
Toll-Free 1-888-313-2665

Visit us on the Internet at www.arcadiapublishing.com

For Sarah: my wife, my love, and my constant inspiration

Contents

Acknowledgments		6
Introduction		7
1.	Homestead	9
2.	The Homestead Steel Strike	25
3.	Munhall	37
4.	Carnegie's Gift	53
5.	West Homestead	73
6.	Life in the Valley	91
7.	The Old Meets the New	107
8.	The Steel Valley Renewed	121

ACKNOWLEDGMENTS

Contrary to popular belief, a project such as this does not just appear. There are dozens of people who contribute both personal and professional resources to make a book such as this possible. I would like to thank Erin Vosgien at Arcadia for putting up with me for a fourth time, Jane Bodnar, Ron Baraff at Rivers of Steel, John R. Fix, Ed Barrett, Rick Drozynski and the staff at Weinberg Village, MDL Insurance, Ginny Buday, the boroughs of Homestead, West Homestead, and Munhall, Gerard Thurman, Marilyn Holt from the Carnegie Library of Pittsburgh, Kate Grannemann and Tyrone Ward from the Carnegie Library of Homestead, George Gula, Larry Levine, Patricia Penka French, Walter W. Kolar, my daughter Samantha, and Bob Metz. A special thanks to Michael and Mary Solomon. Thank you all for your help, support, and dedication to preserving the past.

INTRODUCTION

For a few small towns in western Pennsylvania, Homestead, West Homestead, and Munhall offer an insurmountable amount of history. So much, in fact, that it is nearly impossible to relay it all in one publication. Therefore, I apologize to those who may be disappointed by something that was missed or just not given enough attention, but sometimes there just are not enough hours in the day. This book is dedicated to those who, many decades ago, came to a strange land to start a new life. In doing so, they tolerated unimaginable work conditions without the benefit of sick days or paid vacations. They often endured six- or seven-day workweeks and 12-hour shifts to feed their families here and abroad. Whether they labored in the steel mills and factories of these communities or stayed at home and raised their children, the labors as well as the hardships of these people are the foundation of this country, and we, as a society, can never repay the debt that we owe to those who came before us. What we can and must do is take every opportunity that is presented to us to preserve the memories of the past for future generations. This book and many others like it are just a small attempt toward reaching that goal.

One

HOMESTEAD

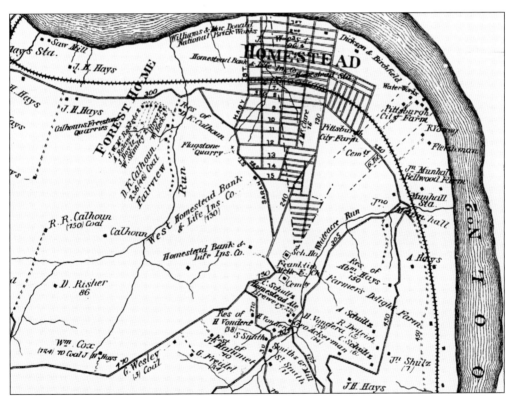

In 1786, John McClure purchased over 300 acres of land at the Monongahela River from Thomas Smith. After the war for independence, land grants were given to soldiers for their service to America. These soldiers included Revolutionary War officer Andrew Lowery, who became one of the first pioneers to what eventually became Mifflin Township in 1788. Until the establishment of the industrial manufacturing companies that produced glass and steel, the area around Homestead was primarily farmland due to its rich soil. Above is an 1876 map of the Homestead area. (Carnegie Library of Homestead.)

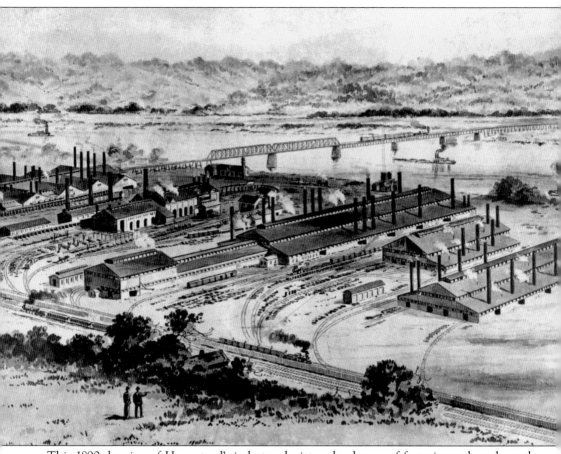

This 1890 drawing of Homestead's industry depicts a landscape of factories and smokestacks. These companies included the Bryce, Higbee and Company glass factory, and the Carnegie Steel Company. In 1890, the population of the borough of Homestead was 7,900, but by the end of 1900, that number had grown to over 12,000. Not just Homestead but the Pittsburgh area as a whole had become the destination where work was available for immigrants and their families. Homestead, like many other industrial communities, had become the starting point and the promise for a new life in America. (Carnegie Library of Homestead.)

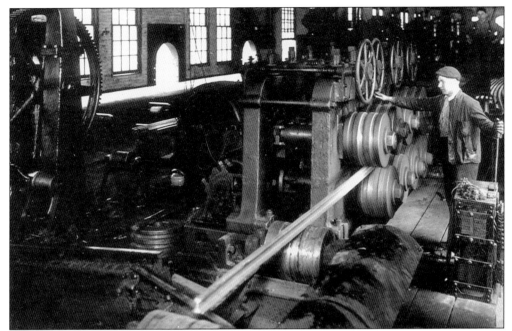

In 1883, Andrew Carnegie bought out the Pittsburgh Bessemer Steel Company for $350,000. Immediately after his purchase, Carnegie ordered the renovation and modernization of the plant. Local as well as national newspaper writers correctly speculated that the purchase was Carnegie's attempt to "corner the steel manufacturing industry." (Carnegie Library of Homestead.)

After the renovation and expansion of the mill, the Homestead Works experienced a production growth with the construction of a 38-inch blooming mill and a 42-inch, a 48-inch, and a 128-inch plate mill in two years. Above are the tie shop and tie plate grinders. (Carnegie Library of Homestead.)

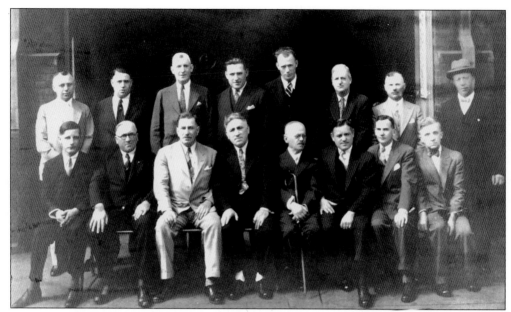

Andrew Carnegie's success not only brought prosperity to himself but also to the borough. With the increased need for employees in the steelworks came the need for more housing and goods. From home builders, landlords, and storekeepers, this success was shared by many. Shown here is the 1930 Homestead Borough Council. (Carnegie Library of Homestead.)

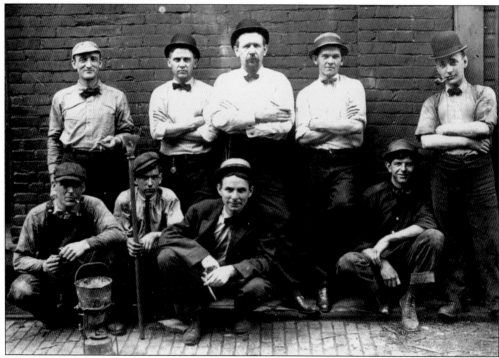

A true melting pot of different ethnicities and cultures, Homestead was built and maintained by immigrants from Ireland, Scotland, Germany, Bulgaria, Slovakia, and many other European countries. (Carnegie Library of Homestead.)

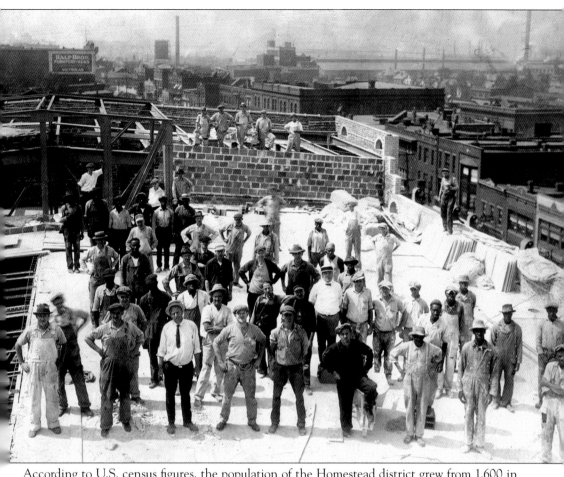

According to U.S. census figures, the population of the Homestead district grew from 1,600 in 1880 to over 45,000 in 1920. (Carnegie Library of Homestead.)

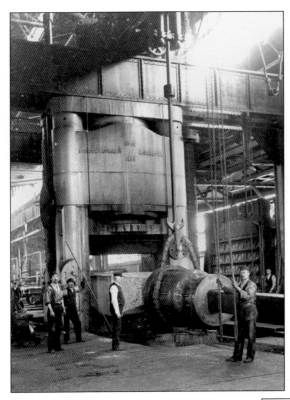

In 1920, the Homestead area was described as "the home of America's steel industry where giant blast furnaces vent their smoke as greedy open hearths consume molten metal and pour forth the hot steel which rings such a tremendous acclaim from great rolling mills." (Carnegie Library of Homestead.)

At the beginning of the 20th century, there were 22 churches in Homestead, including six Methodist and four Catholic. Pictured here is a 1941 photograph of St. Gregory's Russian Orthodox Church on Fourth Avenue. (Carnegie Library of Homestead.)

In 1891, there were six suburban schools broken into three wards and two parochial schools. The average school principal made $1,400 per year with the average teacher salary at about $55 per month. A writer for a Pittsburgh newspaper said of the schools here, "Splendid educational facilities are offered to the youth of the Homestead District." (Carnegie Library of Homestead.)

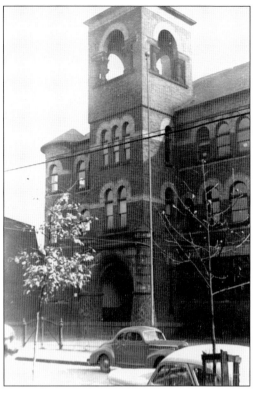

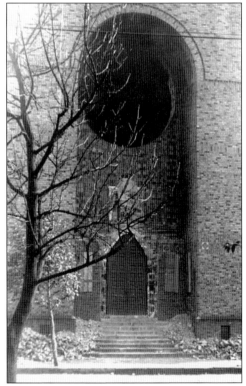

Many important structures were sacrificed for the expansion of the mill. One of them was St. Ann's Roman Catholic Church on Fourth Avenue. (Carnegie Library of Homestead.)

The First Baptist Church, pictured here at the corner of Fourth Avenue and Amity Street, was one of three Baptist churches in the area. (Carnegie Library of Homestead.)

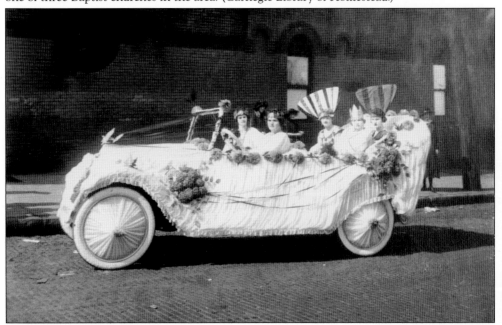

Pictured here is the Lithuanian contingent in the Homestead American parade that was held on the Fourth of July in 1928. (Carnegie Library of Homestead.)

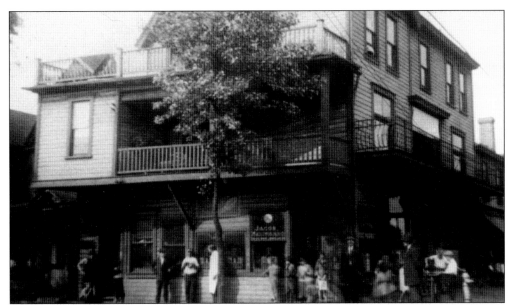

In the 1940s, a newspaper article described Homestead as follows: "The steady growth of the district, the wonderful industrial opportunities and its favorable location have all contributed to the development of the commercial side of the community's life. All phases of business life are represented and Homestead has one of the best and busiest commercial thoroughfares in the Monongahela Valley." Seen here is the Jacob Maximanko building. (Carnegie Library of Homestead.)

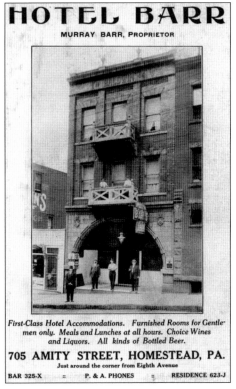

By 1920, there were 27 hotels and legally licensed rooming houses and boardinghouses in Homestead. It was believed that there were twice as many flophouses or "squat" houses that charged exorbitant prices for their rooms. These places were known to take advantage of the newly arrived non-English-speaking immigrant workers. (Carnegie Library of Homestead.)

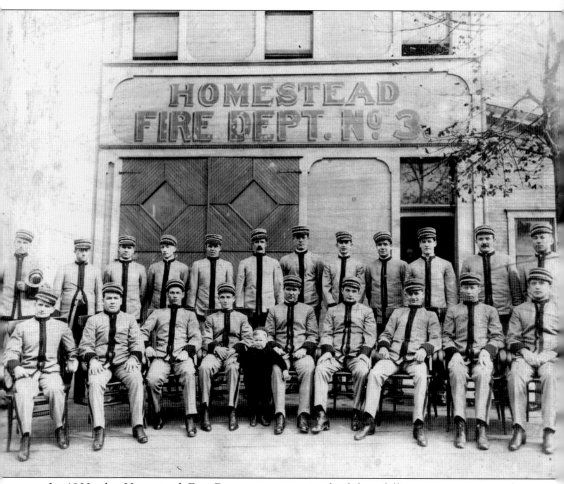

In 1900, the Homestead Fire Department consisted of four full-time companies and over 60 firefighters. Other local municipalities offered "sufficient volunteer companies to serve their communities." (Carnegie Library of Homestead.)

In 1900, the Homestead Fire Department had 54 fire alarm boxes in operation throughout the district. Whenever an alarm was activated at one of these boxes, a "screecher" was blown three times except on Sunday night from 7:00 until 9:00 p.m. (Carnegie Library of Homestead.)

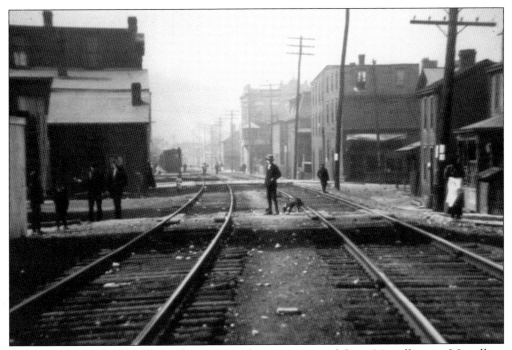

Between 1941 and 1946, the mill's ingot production increased from 3.1 million to 3.9 million tons. This increase was due largely to the plant's expansion for the increased production effort for World War II. (Carnegie Library of Homestead.)

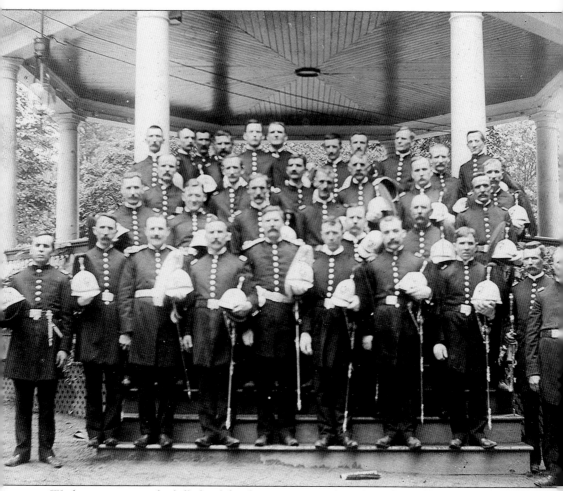

Workers were not only skilled in labor but many were also talented in other areas. Pictured here is the Homestead Steel Works Band in 1912. From parades to award and dedication ceremonies, one could always find the Homestead Steel Works Band. (John R. Fix.)

One of the many local stores and shops that thrived on the success of the Homestead Works was the Natter Bakery. Emigrating from Germany in 1892, Franz Natter and his wife worked to build a family business that included two locations in Homestead. (Thomas Whanger.)

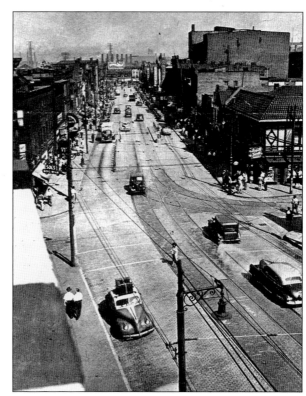

Long gone are the days when the main street through Homestead was nothing but a wet and muddy track. A reporter once wrote that if a horse slipped in the mud on the avenue, it would surely drown before rescuers could get it back on its feet. (Carnegie Library of Homestead.)

In October 1947, the United States Steel Homestead Works hosted an open house for the community, vendors, and employees and their families. At the end of the three-day event, more than 56,000 visitors, including over 8,000 schoolchildren, were able to tour the facility and see the steelmaking process up close. The open house showcased the use of steel in building construction, steel manufacturing for military applications, and General Motors Corporation's "Train of Tomorrow." (Ginny Buday.)

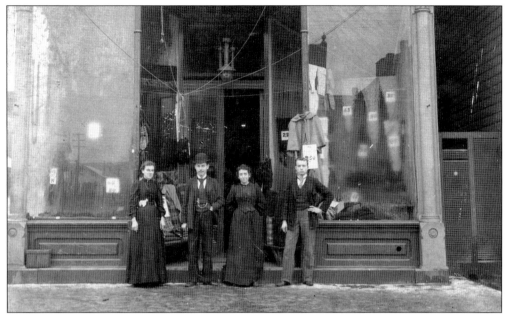

The main road through Homestead, Eighth Avenue, has undergone many improvements over the years. In the 1940s, it was planned that the entire business community was to be given a facelift to showcase all that Homestead had to offer. This renovation would include the cleaning of the buildings' exteriors, storefront modernization, and the installation of a $25,000 sewer project. (Carnegie Library of Pittsburgh.)

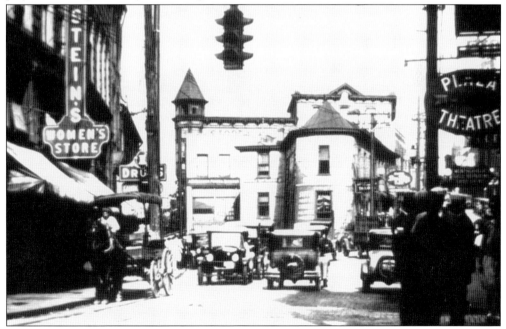

Always the hub of activity, Homestead's Eighth Avenue was one of the busiest streets outside of the city of Pittsburgh. Hosting everything including doctors' offices and department, clothing, drug, jewelry, and food stores, there was little need to travel outside the borough for a family's needs. (Carnegie Library of Pittsburgh.)

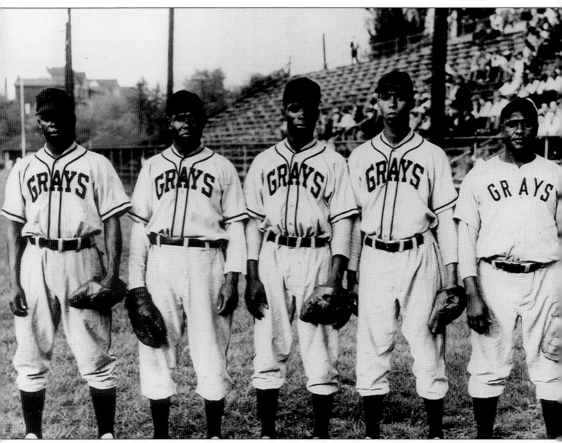

The Homestead Grays baseball team, pictured here in 1949, was originally formed in 1900 by a group of young men who loved the sport so much that they started the Blue Ribbons industrial league team. In 1912, that team became the Homestead Grays, wowing crowds of fans young and old alike with their skill. They won their league pennant nine years in a row and boasted future baseball hall of famers Buck Leonard and Josh Gibson. (Carnegie Library of Homestead.)

Two

THE HOMESTEAD STEEL STRIKE

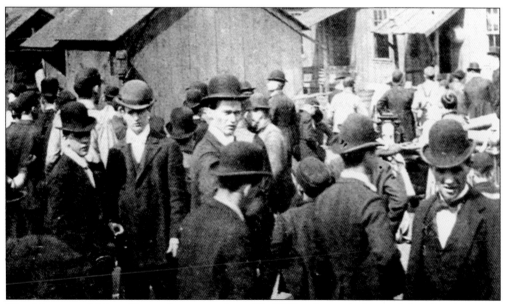

The Homestead labor dispute began on June 29, 1892, when members of the Amalgamated Association of Iron and Steel Workers went on strike against the Carnegie Steel Company after being told that Carnegie proposed a wage cut to employees of the mill. The company's manager at the time, Henry Clay Frick, hired 300 men from the Pinkerton Detective Agency to protect the mill property and its strikebreakers. On July 6, a barge carrying the Pinkerton men arrived at the steel plant on the Monongahela River where a great battle ensued, killing some and wounding many others. The Homestead steel strike remains important to local history not just because of the struggles of labor and the common man but also due to its effect on unions and the steel industry for decades. (Carnegie Library of Pittsburgh.)

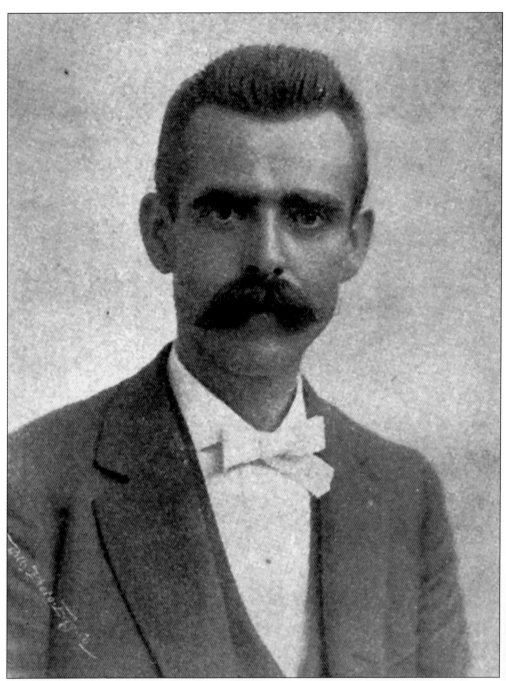

Hugh O'Donnell, pictured here, was a well-respected man in the Homestead area. He was charismatic and an accomplished orator, working as a newspaper reporter prior to his position on the advisory committee with the Amalgamated Association of Iron and Steel Workers. It was surely these and other traits that got him elected by his peers as head of the association's strike committee. After the strike and labor dispute, O'Donnell and others were subsequently blacklisted, never again to work in the steelmaking industry. He eventually moved his family to the Midwest where he became a reporter for the *Chicago Journal*. (Carnegie Library of Pittsburgh.)

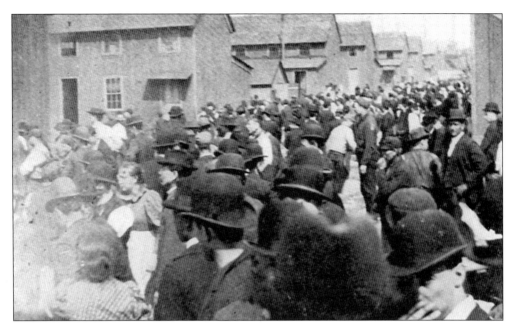

Formed in 1876, the Amalgamated Association of Iron and Steel Workers was a union that represented iron- and steelworkers. The union's initial purposes included the regulation of work hours and wage scales that benefited the employees but also assisted companies in finding skilled workers for specific jobs. However, as the union grew stronger, relations between the association and management grew strained. By the 1892 strike in Homestead, the union was strong and well organized. (Carnegie Library of Pittsburgh.)

Although Andrew Carnegie was publicly for the workingman and a supporter of a strong union, in 1881, he put Henry Clay Frick in charge of the Homestead Works operations, knowing full well that Frick was dedicated to breaking the union's association and to "reorganiz[ing] the whole affair." (Carnegie Library of Pittsburgh.)

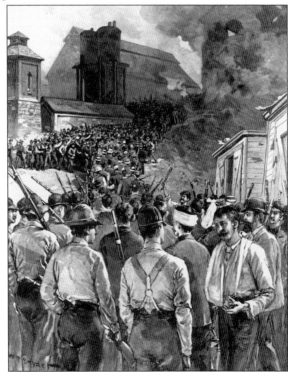

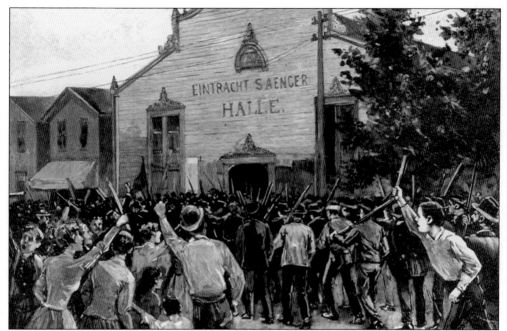

When Henry Clay Frick met with the leaders of the union, the association immediately asked for a wage increase, knowing that Andrew Carnegie's mills were operating at a profit since the steel industry as a whole was doing very well. To this offer, Frick countered with a 22 percent wage cut. (Carnegie Library of Pittsburgh.)

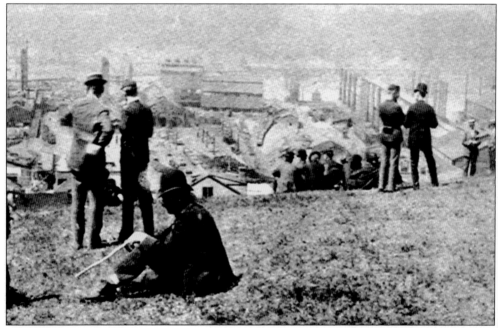

On April 30, 1892, Frick added insult to injury by giving the union a month to come to an agreement with the Carnegie Steel Company. With no agreement reached, Frick locked out all union employees on June 29. All this was done with not only Carnegie's knowledge but also his blessing. (Carnegie Library of Pittsburgh.)

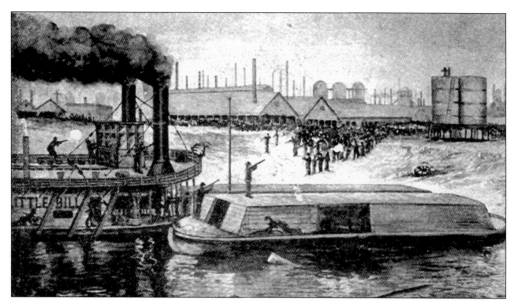

Anticipating the need for security, Henry Clay Frick had contracted with the Pinkerton Detective Agency in April, nearly two full months before labor negotiations even began. With the help of these "hired enforcers," Frick's intent was to open the steelworks with nonunion labor to meet operational quotas. Few, if any, of the Pinkerton agents knew the purpose of their mission. They were about to enter a hornet's nest. (Carnegie Library of Pittsburgh.)

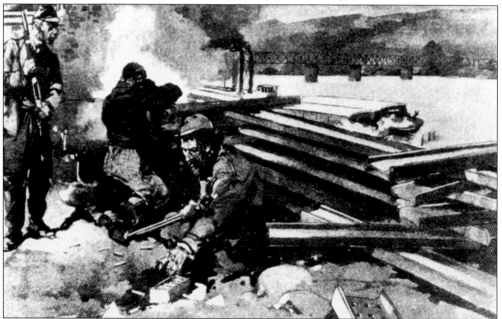

Armed with issued Winchester rifles, the 300 Pinkerton men were floated upriver from the Davis Island Dam hoping to land quietly under the cover of darkness at about 4:00 a.m. The element of surprise was lost when the union discovered the Pinkerton plan, and at 2:30 a.m., the plant whistle was blown, alerting the community. It is unclear which side fired the first shot, but what is known is that during the 10-minute gun battle that ensued, causalities on both sides were reported as 12 dead and 11 wounded. (Carnegie Library of Pittsburgh.)

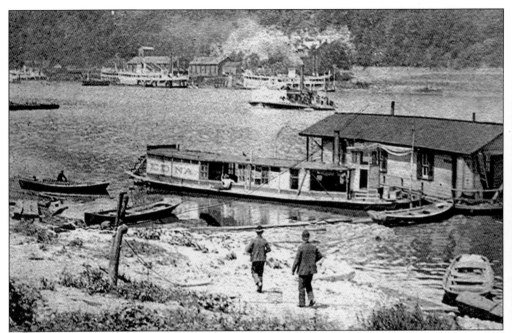

After the initial melee, the strikers, aided by many townspeople, continued to shoot at the Pinkertons, setting up makeshift ramparts and even a cannon on the other side of the riverbank. Reports stated that hundreds of townspeople, including many women, were heard shouting, "Kill the Pinkertons!" (Carnegie Library of Pittsburgh.)

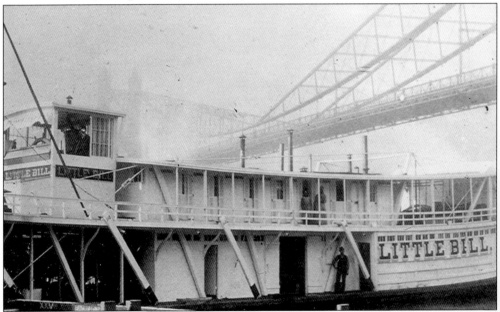

As fighting persisted, there were more casualties on both sides as the gun and cannon fire continued. It was soon evident to the Pinkerton men that they were fighting a losing battle. They were outnumbered, outgunned, and cut off without the chance for escape as gunfire kept tugboats from removing their barges from harm's way. Pictured here is the barge *Little Bill*. (Carnegie Library of Pittsburgh.)

There were many attempts to assail the Pinkerton men and their barges. These attempts not only included continued gun, cannon, and dynamite assaults but also assaults by flame. In the afternoon, oil was poured into the river and lit, and a flatcar loaded with drums of oil was set ablaze and sent hurtling toward the barges on the dock. (Carnegie Library of Pittsburgh.)

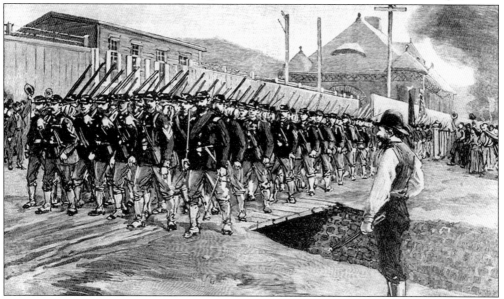

On July 7, upward of 5,000 people from surrounding towns such as Duquesne, Braddock, and Pittsburgh were now in Homestead to support the strikers. Their sympathies were clearly with the locked out workers and their families—that is until the Pinkerton agents surrendered. At about 5:00 p.m., the agents raised a white flag and were promised safe passage through town by Hugh O'Donnell himself, but when they tried to pass through the angry crowd, the men were severely beaten with clubs and rocks. Seen here, the militia marches in to restore order. (Carnegie Library of Pittsburgh.)

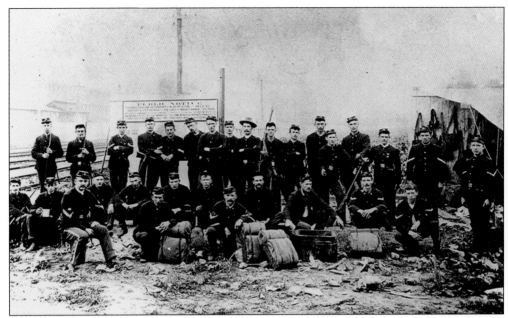

Although Gov. Robert Emory Pattison had been informed by the union leadership that order had been restored, he had been told otherwise by the Carnegie Steel representatives who urged the governor to send troops to protect the interests of the company. On July 12, 4,000 troops arrived in Homestead and immediately restored order to the mill. Pictured here is the 14th Pennsylvania National Guard. (Carnegie Library of Homestead.)

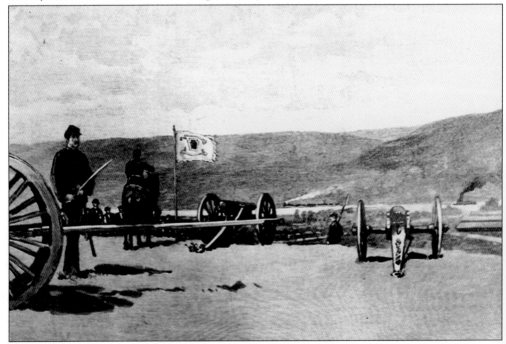

Within a day of the arrival of the state militia, the plant was secured and replacement workers, or scabs, were brought in by Henry Clay Frick to restart steel production. On July 15, the furnaces were relit and production was underway once again. (Carnegie Library of Homestead.)

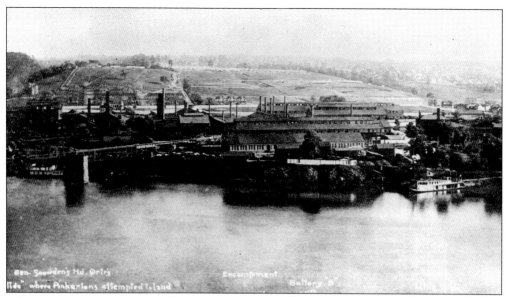

After the arrival of the militia, there was only one small incident where a few strikers attempted to breach the mill gate. They were repelled by the soldiers who wounded six by bayonet. (Carnegie Library of Homestead.)

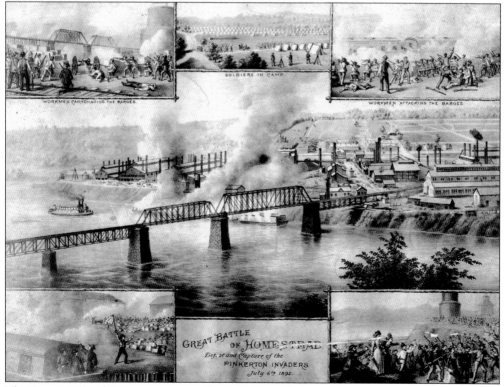

The Carnegie Steel Company was not the only side to declare victory in the battle of Homestead as the above poster reflects, stating, "Defeat and Capture of the Pinkerton Invaders, July 6th, 1892." (Carnegie Library of Homestead.)

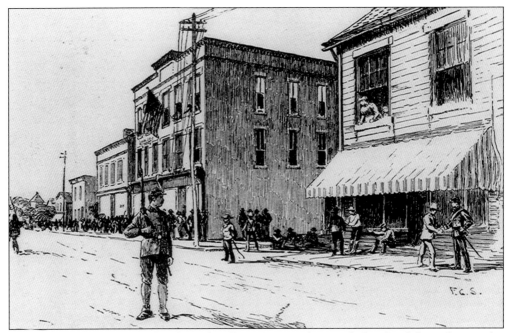

Pictured here is Homestead's telegraph office. One resident said that he did not know who there were more of—angry workers and those who came from far and near to support them or newspaper men at the telegraph office anxious to tell the story. This three-story structure, the Bost building, is now home to the offices, archives, and exhibits of the Steel Industry Heritage Corporation. (Carnegie Library of Homestead.)

Little did anyone know that as events unfolded in Homestead, it was the media that shaped how the nation viewed the struggles of labor and not the union, company management, or the involvement of the Pinkertons. Until the surrendering Pinkertons were beaten, sympathies were with the union workers, but when newspapermen reported the abuse suffered by defenseless men at the hands of a "blood thirsty mob," many attitudes were changed. Here strikers escort a correspondent. (Carnegie Library of Homestead.)

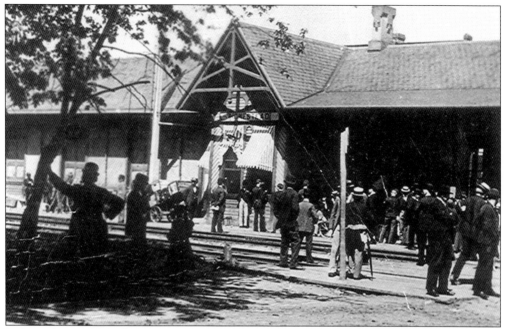

Perhaps due to political pressure from company executives, on July 18, charges were filed against union leaders and the strike committee. Although these charges included murder, attempted murder, conspiracy, and inciting a riot, they were eventually dropped due to their lack of merit. (Carnegie Library of Homestead.)

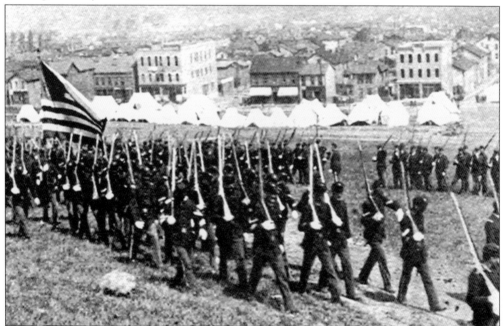

By October 13, support for the strike had diminished, and the state militia was recalled after 95 days of maintaining order. As far as Henry Clay Frick was concerned, the action to lock out strikers and bring in scab labor had been a success. Frick was asked by labor as well as politicians on numerous occasions to reopen negotiations. He refused. (Carnegie Library of Homestead.)

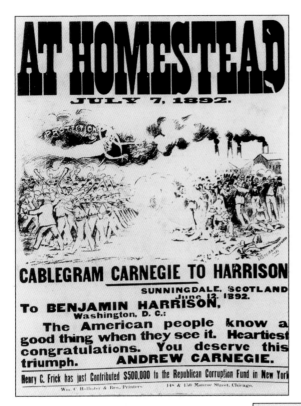

Although the breaking of the labor union was touted as a victory for Henry Clay Frick and the Carnegie Steel Company, one casualty report of the violence that took place on July 6 and 7 concluded that seven laborers and three Pinkerton men were killed with countless wounded. Another unforeseen outcome of the strike was that the Carnegie Steel Company was able to keep its grip on labor and remained a nonunion shop for the next four decades. (Carnegie Library of Homestead.)

On July 23, a Russian anarchist named Alexander Berkman, pictured here, burst into Frick's office and attacked him in an assassination attempt. Berkman was able to both shoot and stab Frick before he was subdued by others in the office. Although it was commonly believed that Berkman acted alone, his attack on Frick was seen by some as yet another way that the union was attempting to take revenge on the company. Frick not only survived the attack, he initially refused treatment for his wounds until his business at hand was completed. (Carnegie Library of Homestead.)

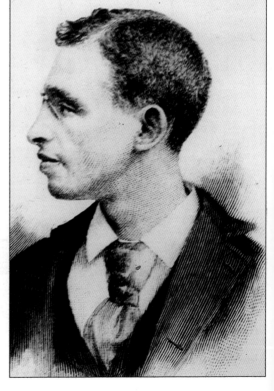

Three
MUNHALL

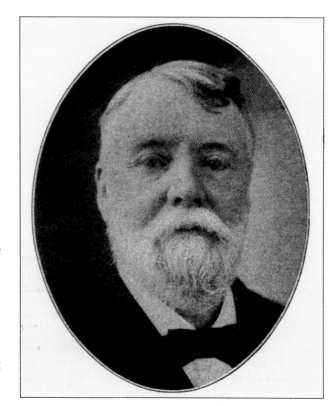

John Munhall's parents were killed in a riverboat accident at Port Perry, now part of modern-day North Versailles Township, when he was just 10 years old. Although his early life was not easy, he quickly became known for his strong work ethic and entrepreneurship. Although his first business venture as a merchant failed due to the depression of 1857, he soon found himself in business with his brothers William and Michael building steamboats. The brothers were also involved in the oil business before settling into a coal venture here in the valley. (Borough of Munhall.)

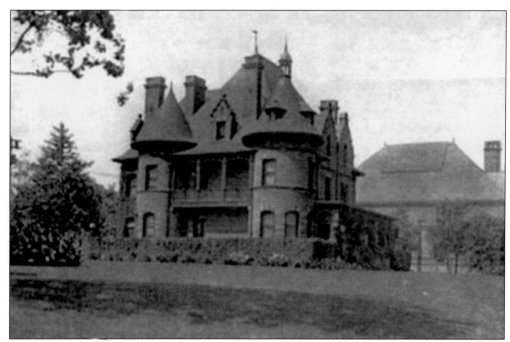

Seen here is a 1910 photograph of the Hunt Mansion, which stood near the Carnegie Library of Homestead. Erected in 1896, initially it was the home of mill superintendent Charles Schwab. It was later the residence of Azor Hunt. (Carnegie Library of Homestead.)

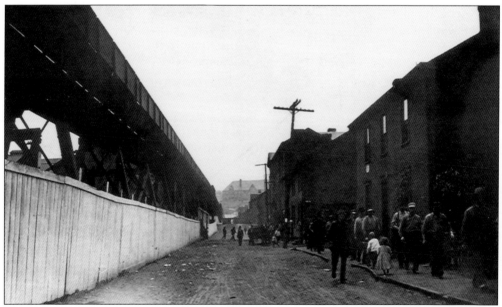

As industry grew in Munhall and the rest of the Steel Valley, so did the population. In 1910, the population of the borough was 5,185. In four decades, it tripled to over 16,000. (Carnegie Library of Homestead.)

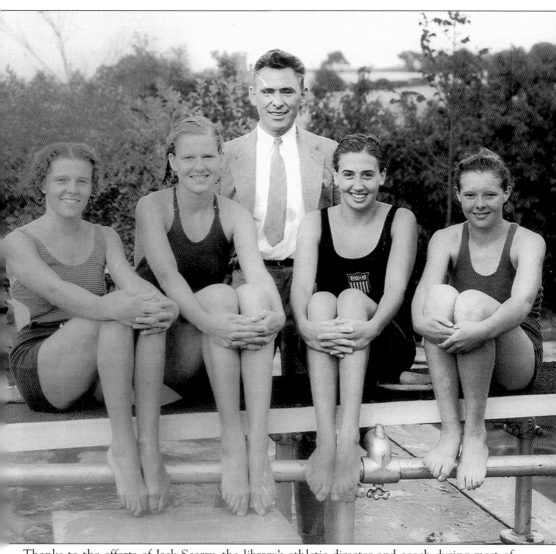

Thanks to the efforts of Jack Scarry, the library's athletic director and coach during most of the first half of the 20th century, athletes such as Anna Mae Gorman, Lenore Kight, Josephine McKim, and Susan Laird represented the United States in the 1928, 1932, and 1936 Olympics in swimming. (Carnegie Library of Homestead.)

Carnegie Steel Company employed social workers in most of the steel towns where it operated a plant. The role of these women included giving comfort and aid to company families in distress, coordinating educational programs for spouses and children, and even assisting with civic and police matters within the community. Pictured here is a woman in 1922 fondly known as Miss Neel, who was also trained in the skills of midwifery. (Carnegie Library of Homestead.)

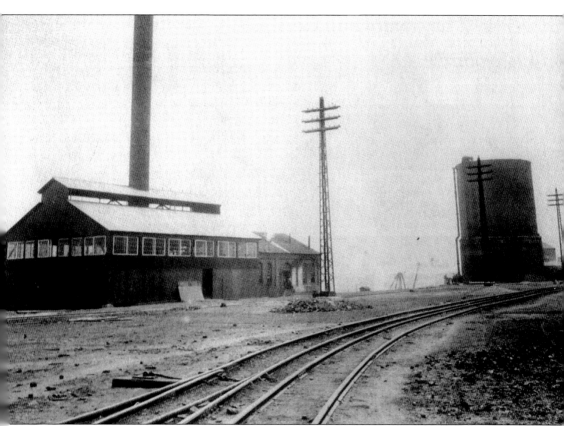
Although the Homestead steel mill was synonymous with the town of Homestead itself, over 90 percent of the mill facility was located in Munhall. (Carnegie Library of Homestead.)

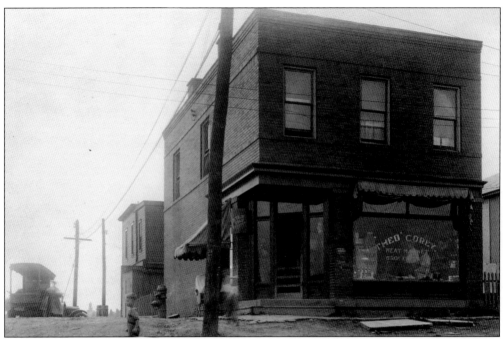

This photograph was taken in 1921 and shows the Theo Corey Meat Market and Grocery located at Twentieth Avenue and Maple Street. Long before the days of super groceries and mega markets, the small neighborhood store met the needs of the community. (Carnegie Library of Homestead.)

The stock market crash and the subsequent depression affected most businesses, including the Carnegie Steel Company. Forced to lay off some of its employees but believing that they would be hired back, the company offered to help distressed furloughed employees and their families. This assistance came in the form of offering food baskets at $2 each against any future earnings. (Borough of Munhall.)

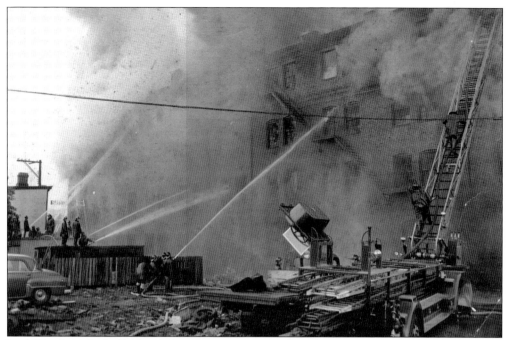

In 1894, the Munhall No. 1 Fire Company was called the East Homestead Volunteer Fire Company. Originally located off Andrew Street, the building consisted of quarters for the buggy and the fire horse that pulled it. (Carnegie Library of Homestead.)

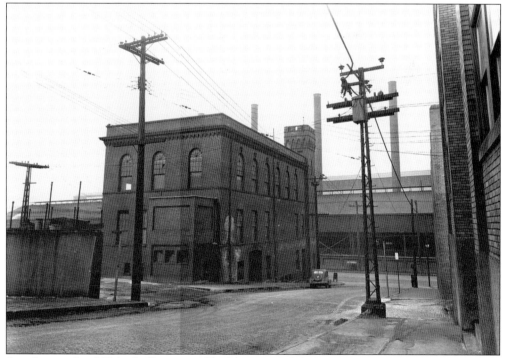

Seen here is the old Munhall municipal building on Eighth Avenue in 1934. Construction began in 1902 at a cost of just over $18,000. (Carnegie Library of Homestead.)

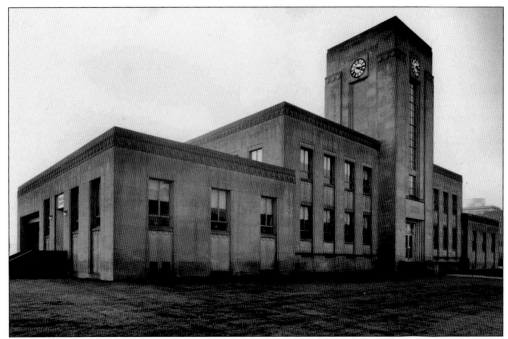

As the town grew so did the need for offices to house the numerous departments that supported the community. The new Munhall borough building, located on West Street, was constructed in 1941 and is now home to the municipal offices. (Carnegie Library of Homestead.)

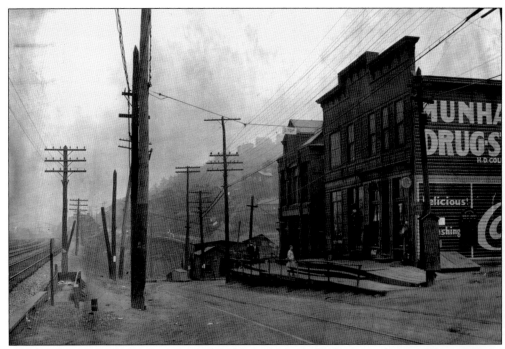

Munhall Junction, shown here around 1900, was Munhall's business district. The corner of Eighth Avenue and Ravine Street was the location of a dry goods store, a hardware store, and a butcher shop. (Carnegie Library of Homestead.)

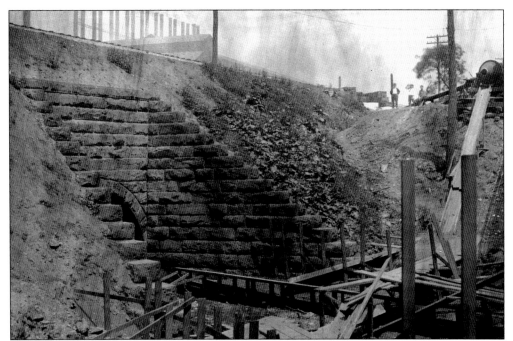

Prior to 1901 and the ratification that made Munhall its own borough, the area was known as East Homestead, a part of Mifflin Township, one of the seven original townships that comprised Allegheny County. (Carnegie Library of Homestead.)

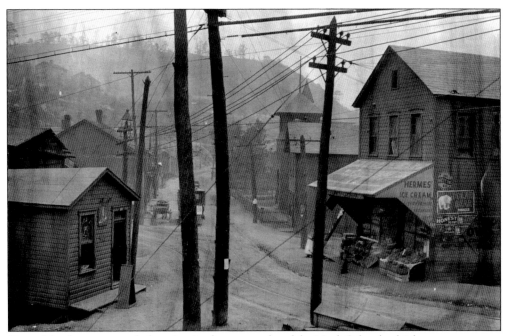

One of the first reports of education in the area spoke of the Neck School, which was a one-room log building around Twenty-second Avenue. Built around 1800, it served not only children of this area but pupils from Dravosburg and Beck's Run, or present-day South Side. (Carnegie Library of Homestead.)

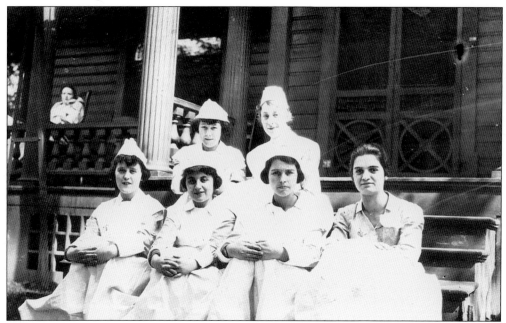

The nurses of Homestead Hospital, as seen here in 1919, were the angels of mercy to many in the Steel Valley. From treating injuries at the Carnegie mill to delivering babies, the staff of the hospital always stood ready to help those in their community. (Carnegie Library of Homestead.)

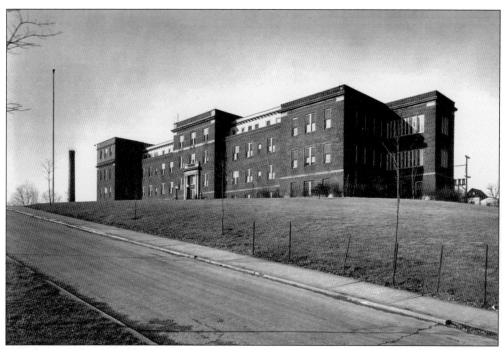

Seen here is Homestead Hospital's second location at 1800 West Street. The hospital was set up initially in 1908 at Hays Street and Ninth Avenue in a remodeled private house. (Carnegie Library of Homestead.)

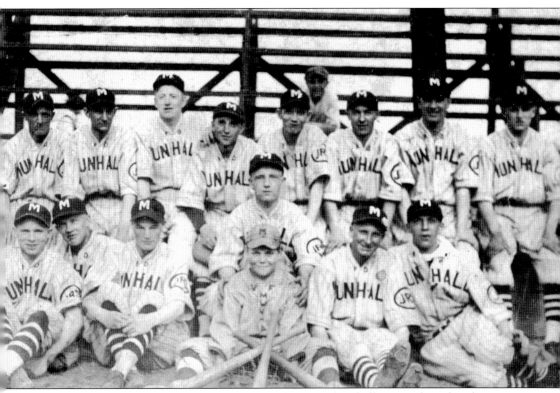

Like many boroughs and towns, Munhall boasted its own baseball teams that played against other local towns' teams. These teams played not for trophies or scholarship monies but the most important prize possible—bragging rights. (Carnegie Library of Homestead.)

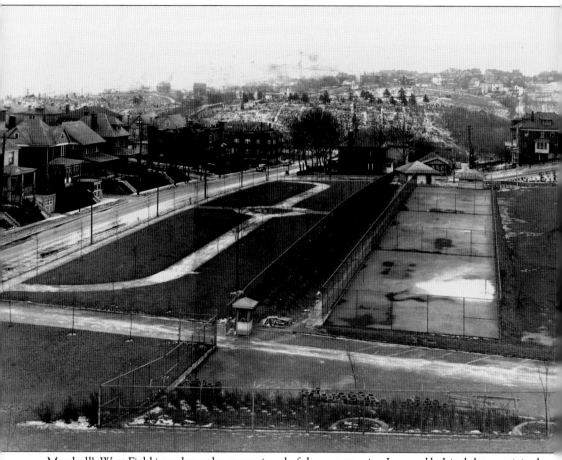

Munhall's West Field is perhaps the crown jewel of the community. Located behind the municipal building, it has, for decades, been the place where kids and adults alike have cheered on their favorite players and rooted for the hometown team. (Carnegie Library of Homestead.)

Pictured here is old Whitaker Way. For many years it was more of a path than a roadway; it was a muddy and narrow road from the top of the hill to Route 837. (Carnegie Library of Homestead.)

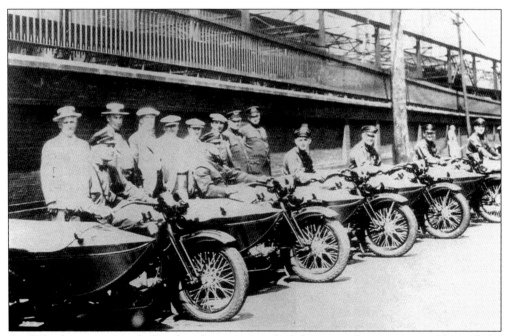

In 1902, the entire Munhall police force consisted of three patrolmen or constables and the police chief. Early police departments such as this were common as most of the calls were related to public intoxications and petty theft. Police were rarely called for domestic disturbances since these problems were usually handled in-house with a rolling pin. (Borough of Munhall.)

As the economy of Munhall and the rest of the Steel Valley boomed, so did the building of new homes. One newspaper advertisement in the early 1940s publicized that "$5,800 bought a smart 5-room home with copper plumbing, hardwood floors and a tiled wall bathroom." (Borough of Munhall.)

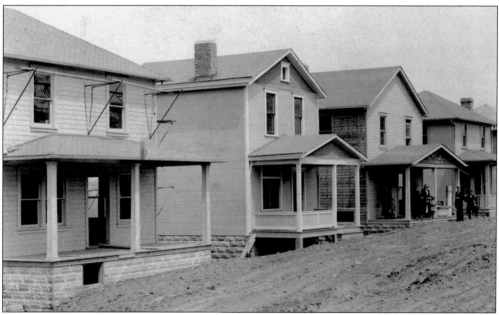

The need for continued housing developments grew as it was estimated that by 1950, 70 percent of Munhall's population was directly employed by or in some way connected to the valley's steel industry that continued to expand. The location of much of the newly developed property was attractive to home buyers due to the quiet locations away from the mills. (Carnegie Library of Homestead.)

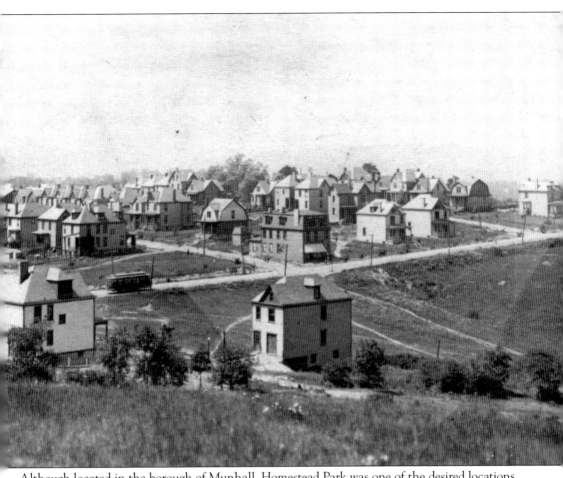
Although located in the borough of Munhall, Homestead Park was one of the desired locations for home buyers in the 1940s and 1950s, as it offered homes with large yards and safe places for children to play away from trucks, trains, and machinery. The children of post–World War II Munhall had it better than many of their parents who grew up in the lower Steel Valley. (Carnegie Library of Homestead.)

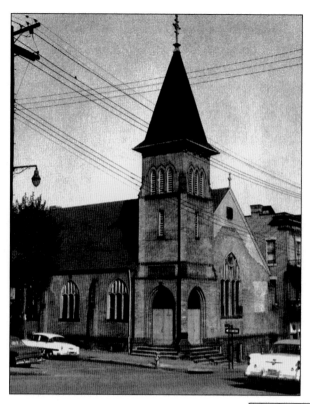

St. Elias Church has served the Byzantine Catholic residents of the greater Munhall area for nearly 100 years. Originally located at McClure Street and Ninth Avenue, St. Elias is now located on Homestead Duquesne Road. (Carnegie Library of Homestead.)

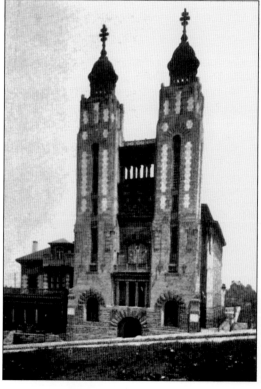

Pictured here in 1946, St. John's Cathedral on Dickson Street was at one time home to thousands of Catholic families of the Croatian, Hungarian, and Greek rite of Lithuanian faiths. The congregation has since moved to a new building on West Run Road. (Carnegie Library of Homestead.)

Four
CARNEGIE'S GIFT

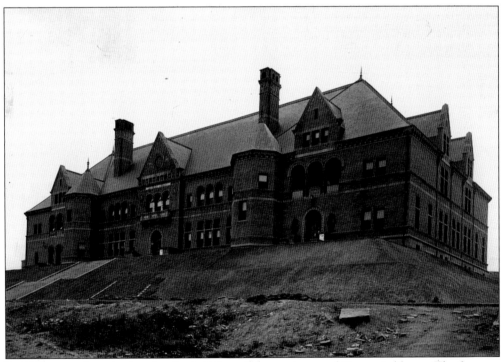

In 1896, ground was broken for the building of the area's second Carnegie library. The first was the library built in Braddock seven years earlier. The Homestead library was constructed at the site of what was the state militia encampment just four years earlier. It was ironic to many in the community that the site utilized by the state militia to enforce the lockout of the workers at the Carnegie steelworks was now to become the location of Andrew Carnegie's gift to the people of Homestead. (Carnegie Library of Homestead.)

Andrew Carnegie's motives to give away millions of dollars to build libraries that were "free to the people" are still debated to this day. After all, this was the man who turned his back on the labor struggle of the common man during the Homestead steel strike. It is often questioned whether Carnegie was struck with the sense that it was important to give back to the community or if he was just trying to "buy his way into heaven." Whatever his motivation, he left behind the legacy that knowledge should be available to anyone, and with knowledge, anything is possible. (Carnegie Library of Homestead.)

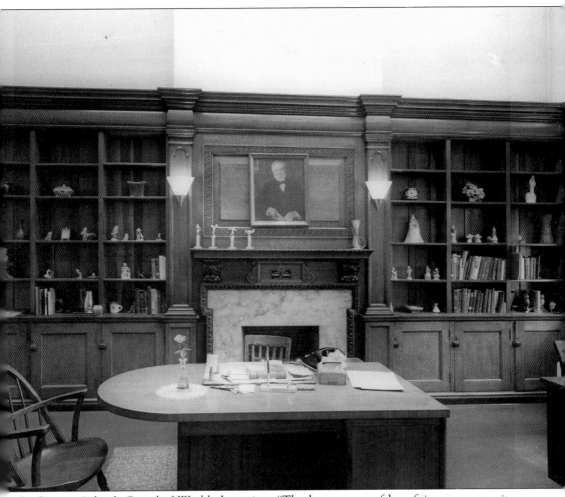

In Carnegie's book *Gospel of Wealth*, he writes, "The best means of benefiting a community is to place within its reach the ladders upon which the aspiring can arise." With these words, Carnegie contributed over $40 million to build 1,700 public libraries across the United States. During this time of philanthropy, it was common belief that any town that wanted a library got a library. (Carnegie Library of Homestead.)

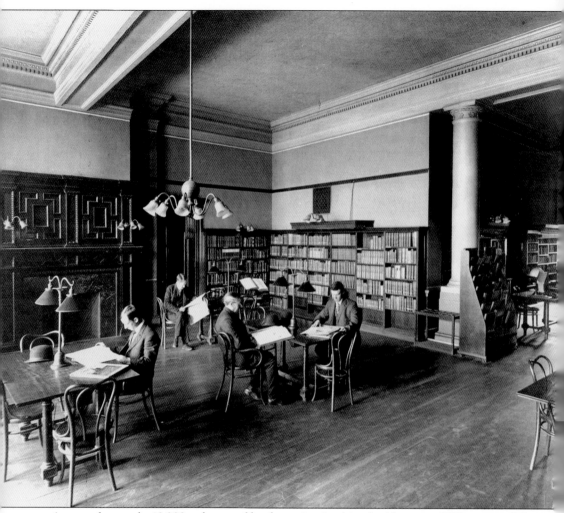

Among the nearly 40,000 volumes of books maintained in the library in 1920, many of these were written not in English but in Slovak, Lithuanian, Italian, French, Hungarian, German, and Polish. Many learned to read at the Carnegie Library of Homestead. (Carnegie Library of Homestead.)

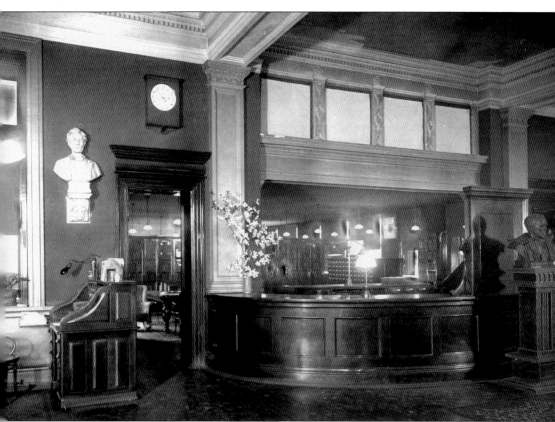

The building was not constructed as just a place to house volumes of books. It was also intended to be a showplace demonstrating the works of skilled craftsmen. Hand-cut Italian marble and beautifully painted murals adorned the walls, setting the backdrop for hand-carved oak desks and cabinets. One can only imagine the awe felt by a first-time visitor stepping into Carnegie's "gift to the people." (Carnegie Library of Homestead.)

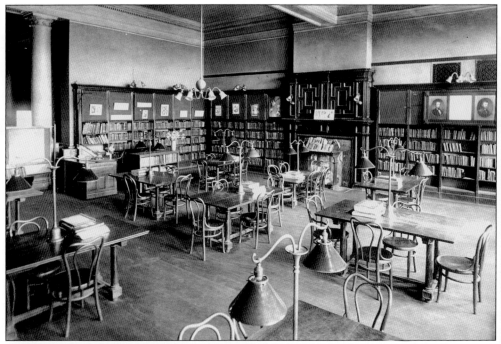

Although the Homestead, Duquesne, and Braddock libraries had athletic facilities with swimming pools, only Homestead's contained a music hall, with a seating capacity of over 1,000. (Carnegie Library of Homestead.)

The building was designed by the architectural firm of Longfellow, Alden, and Harlow, which also designed the Pennsylvania School for the Deaf, the Duquesne Club in downtown Pittsburgh, and the Carnegie Institute. The library was constructed by William Miller and Sons of Pittsburgh at a cost of $250,000. (Carnegie Library of Homestead.)

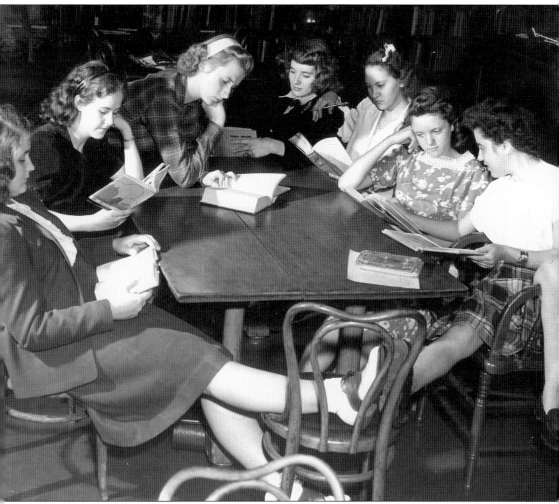

The Homestead library, like most other libraries, was the center of the community and offered a location to meet people and share information. At the library, students were given the chance to study with friends after school or take a class and learn something interesting. As true today as it was 100 years ago, the library opens many doors through thousands of books, magazines, films, videos, computers, and various publications. (Carnegie Library of Homestead.)

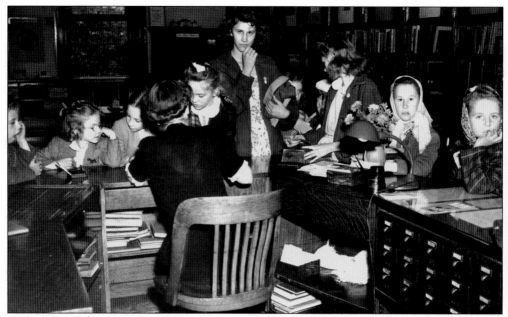

Although Andrew Carnegie was directly credited for giving away millions of dollars for the building of these free libraries, it was, in fact, his secretary James Bertram who oversaw the day-to-day operations and administration of the cash disbursements. As requests for the building of a library came in from communities around the globe, Carnegie himself saw little of the actual correspondence. (Carnegie Library of Homestead.)

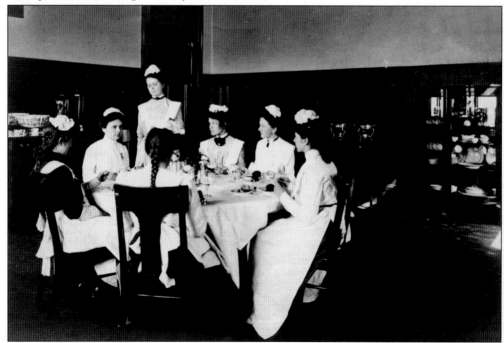

In a domestics class, as seen here, young ladies are educated in the skills of cooking, the proper washing of clothing, ironing, and child rearing. Classes such as household accounting were not offered as this task was the man's responsibility in 1910. (Carnegie Library of Homestead.)

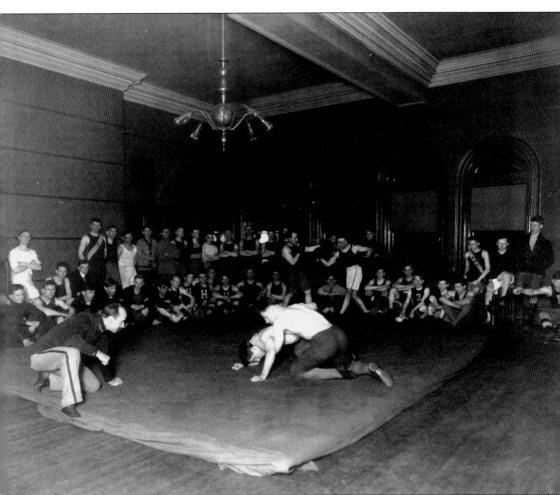

As part of the community, the Homestead library was host to many activities. These included wrestling (shown here), boxing, gymnastics, swimming, and bowling. At one time or another, the library also sponsored its own baseball, football, and basketball teams. Carnegie believed strongly in not only strength of the mind but also strength of the body. (Carnegie Library of Homestead.)

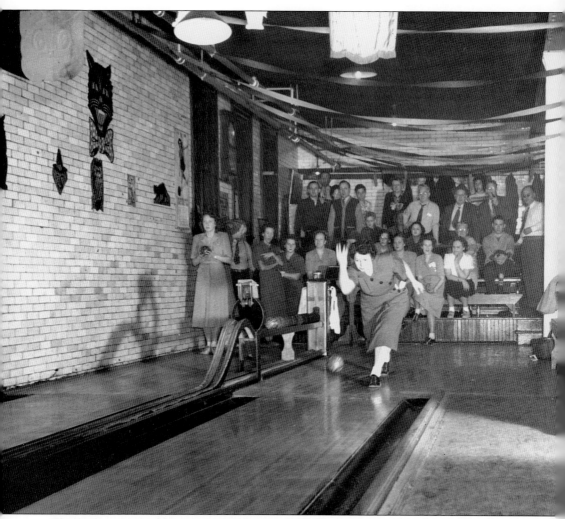

The facilities at the library were open to any and all who lived and worked in the community. At the height of the library's heyday, one count of literary and study organizations revealed that there were 41 different clubs with a total of nearly 1,500 attendees who used the facilities. These numbers did not take into account the various sports and athletic organizations or the Steel Valley's 600 Boy Scouts that set the library as their headquarters. (Carnegie Library of Homestead.)

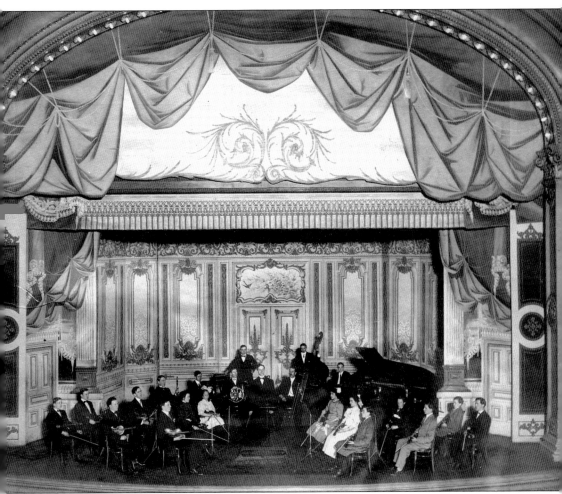

When the library was opened in 1898, the *Homestead Messenger* reported that it was a "proud day for Homestead. The people of Homestead did themselves proud on Saturday with their magnificent demonstration in honor of Andrew Carnegie." The article went on to say, "Thousands of people standing on the sidewalks for hours in a down-pouring rain watching thousands of school children soaked to the skin plodding in mud almost up to their shoe tops, followed by hundreds of mill men, business men, professional men and in fact men in all walks of life, told as nothing else could the gratification felt towards Mr. Carnegie for his magnificent gift." (Carnegie Library of Homestead.)

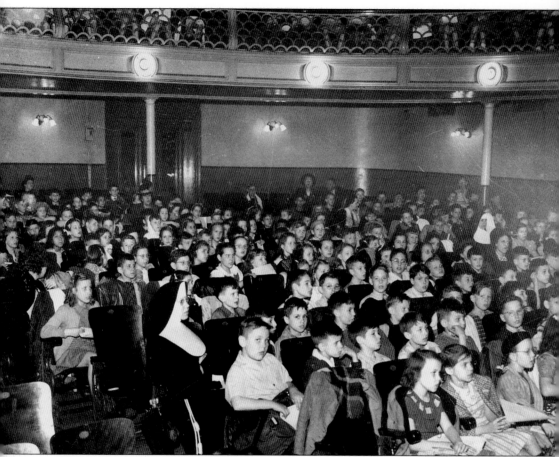

Culture and entertainment were very much a part of Andrew Carnegie's vision as well. The music hall, seen here, was described by librarian William Stevens upon the building's opening as well thought out with its decoration. "The main foyer has yellow Verona marble walls, the ceiling being of harmonious color while white marble stairs lead up each side of the balcony floor." (Carnegie Library of Homestead.)

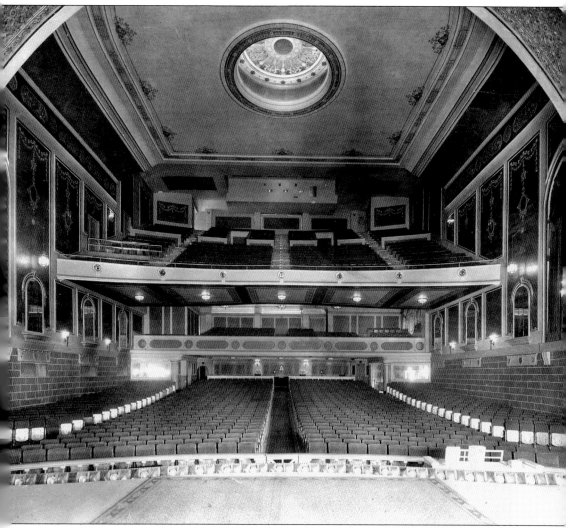

The stage of the music hall hosted many productions and community functions throughout the years. Its construction is unique as it has a 10-degree slope enabling the conductor to see all the members of the band or orchestra. Its dimensions are an impressive 40 feet wide and 33 feet deep. The stage's arches were described as "done in ivory and gold, the latter used so that a brilliant, not vulgar effect is maintained." Nearly as grand as the Carnegie library music hall was the Leona Theater, pictured here. (Carnegie Library of Homestead.)

The Carnegie Library of Homestead provided an environment for a fit body and a strong mind, also affording the opportunity for a clean body as well. Every Saturday night many could be seen, soap and washcloth in hand, making their way to the library bathhouse. (Carnegie Library of Homestead.)

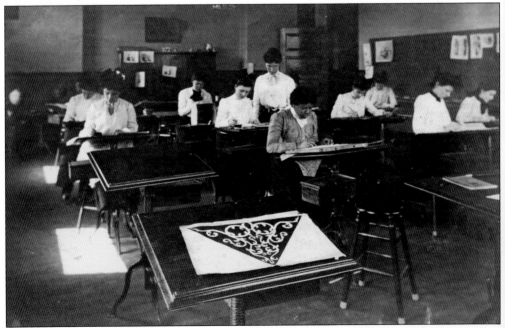

The library offered many educational and recreational classes to library members as well as nonmembers. For a slight fee, nonmembers could take a class in painting, sculpture, macramé, knitting, or crocheting. Most of these craft classes were free to library members. (Carnegie Library of Homestead.)

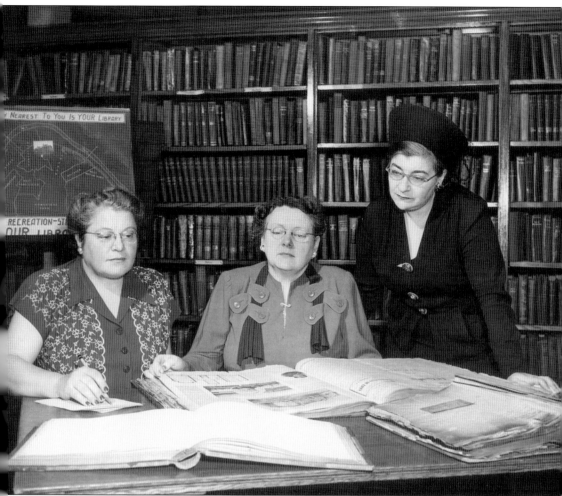

After the building of the first few libraries, including Homestead, Andrew Carnegie mandated that the communities that received one of his benefactions be required to take an active role supporting the daily function of the library. The requirement was usually a yearly pledge of at least 10 percent of the cost of the initial building. These monies were usually collected by library staff and administrators and were the fees charged by the various athletic and literary associations within the library. (Carnegie Library of Homestead.)

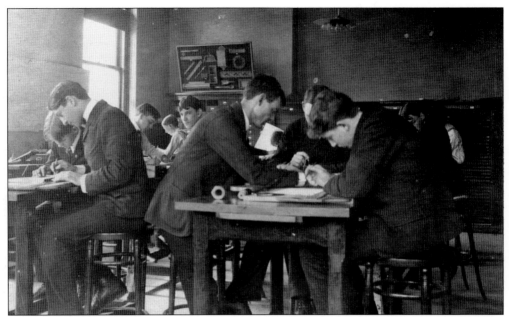

In August 1932, Rev. H. M. Eagleson of the Whitaker Methodist Episcopal Church launched a new concept in education. In an attempt to help the youth of the community find jobs during the Depression, Eagleson established the Depression University. Its goals were to train and educate students by exposing them to books and area educators who donated their time and expertise. (Carnegie Library of Homestead.)

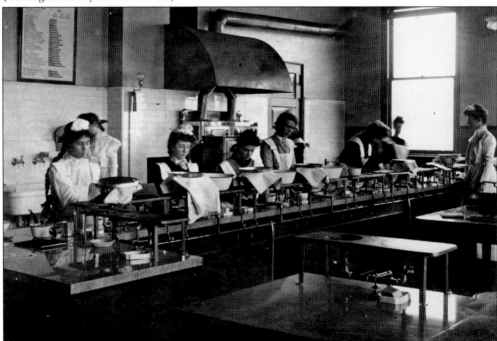

At the Depression University, students were offered instruction in economics, history, child training, and advanced math and science, as well as business law and public speaking. (Carnegie Library of Homestead.)

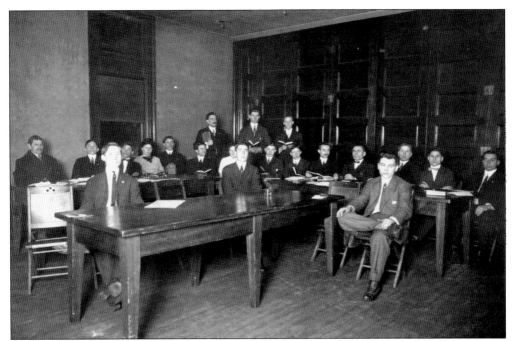
Although there were no formal degrees awarded to the students, the facilitators turned down no student who was willing to put forth the effort to learn. One-third of the 500 students were women with two-thirds between the ages of 18 and 25. (Carnegie Library of Homestead.)

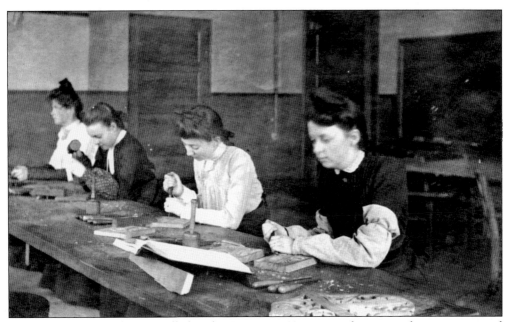
In addition to the students enrolled in the Depression University, there were also many men and women attending the Charles Schwab School. This school offered a more specific curriculum in courses such as drafting, business practices and ethics, and English speaking for foreign students. Many of these classes were specifically geared toward those employed at the mill. (Carnegie Library of Homestead.)

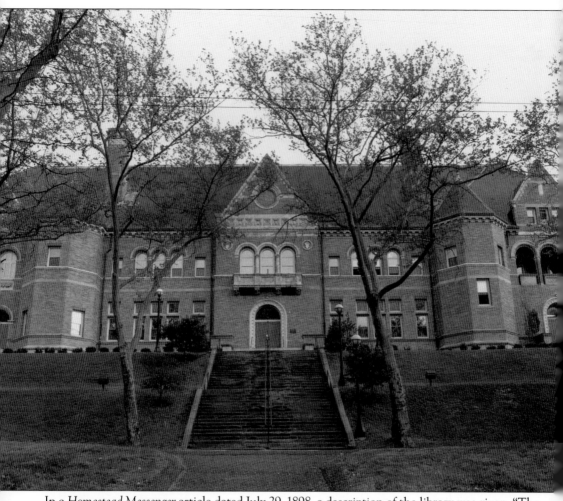

In a *Homestead Messenger* article dated July 29, 1898, a description of the library was given. "The visitor reaches the main entrance by a long flight of steps from the upper side of Tenth Avenue. The scene presented inside is first the delivery desk which is semi-circular in shape and made of elegant hardwood. To the rear of the desk are glistening cases with plate glass doors that are most imposing while the bright colors of the thousands of books in view add beauty to the grandeur." (Carnegie Library of Homestead.)

Always eager to help, the staff of the Carnegie Library of Homestead has stood at the ready to serve its patrons. Without the dedication of these people, including paid staff and volunteers, many would be truly lost. (Carnegie Library of Homestead.)

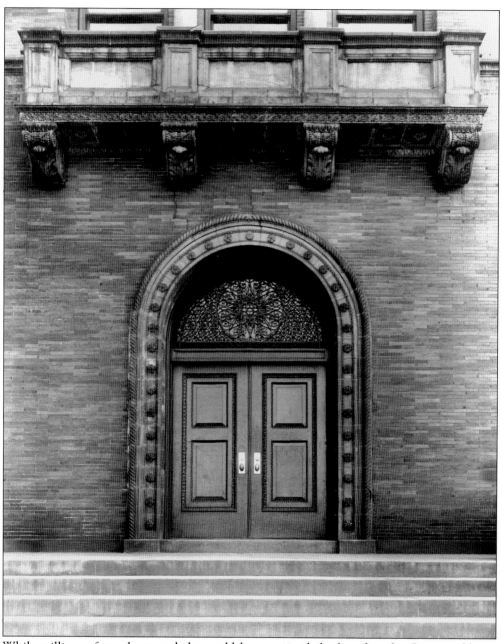

While millions of people around the world have enjoyed the benefits of a Carnegie library over the past century, many people could not forgive the industrialist for his actions during the Homestead steel strike of 1892. Although many towns and communities embraced Andrew Carnegie's generosity, an editorial in a St. Louis newspaper stated, "Ten thousand Carnegie Libraries would not compensate the country for the direct and indirect evils resulting from the Homestead lockout." Closer to home, a Pittsburgh labor leader said that he would sooner enter a building constructed with the dirty silver that Judas received from betraying Christ than enter a Carnegie library. (Carnegie Library of Homestead.)

Five
WEST HOMESTEAD

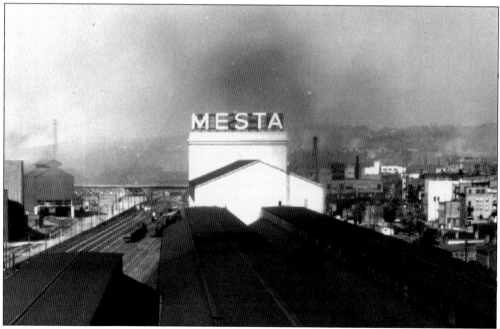

One of the first settlers to come to the area when Mifflin Township was established was David Calhoun, a Scotch-Irish immigrant who built a log cabin as his first residence. His second house was constructed of brick in 1874 on Eighth Avenue. The site of this residence later became the location of the Calhoun Junior High School. Calhoun, like many other soldiers of the American Revolution, was awarded land grants for his service. (Carnegie Library of Homestead.)

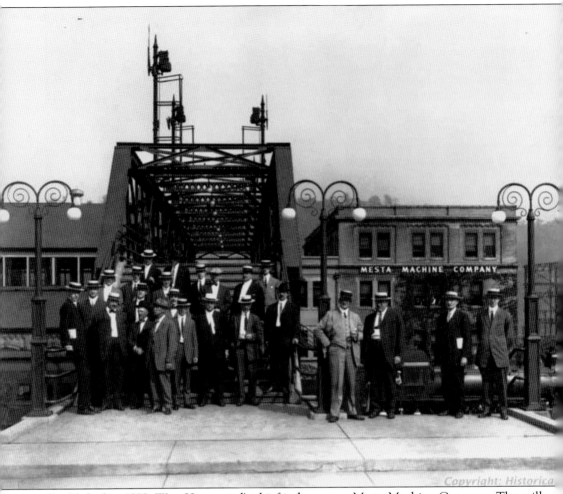

Established in 1898, West Homestead's chief industry was Mesta Machine Company. The mill was founded by George Mesta along the Monongahela River where WHEMCO now stands. One description of the plant in 1904 described the facility by saying, "All buildings are fire-proof, only steel, concrete and fire brick having been used in their construction. Work can never be delayed on account of fire, a feature as important to our customers as ourselves." (Carnegie Library of Pittsburgh.)

Erected in 1902, the West Homestead municipal building, seen here, was built on the corner of Eighth Avenue and Howard Street. It was the home to the police station, municipal offices, and fire department. (Borough of West Homestead.)

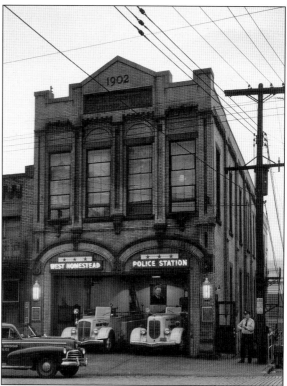

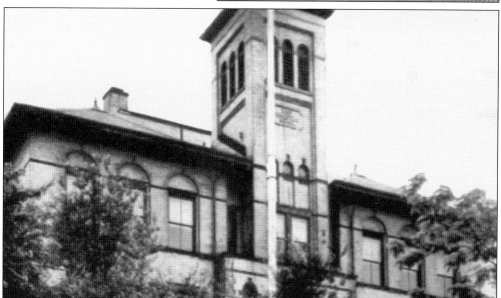

Henry Clay Frick remains well known for his actions at the Homestead Works of Carnegie Steel during the strike of 1892. What is not common knowledge is the fact that after the smallpox outbreak of 1902, it was decided that a hospital was needed in the West Homestead area. Construction for the facility located at Ninth Avenue and Hays Street was completed in 1908 with $500,000 donated by Frick himself. Pictured here is the Walnut School, built in 1901 shortly before the smallpox outbreak of 1902. (Borough of West Homestead.)

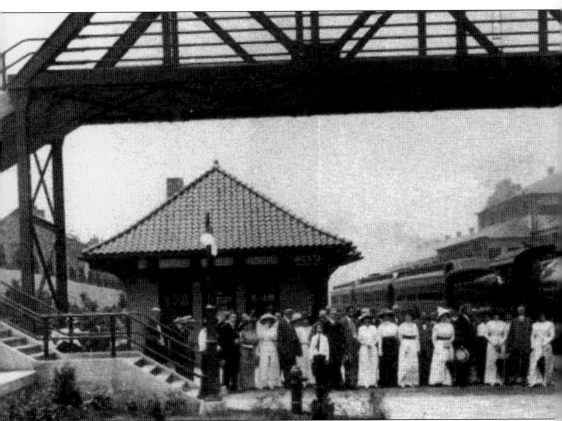

Like many communities that were a hub of activity, West Homestead was not the exception when it came to accidents and injuries inside as well as outside the mills. At the beginning of the 20th century, many of these accidents took place on or near the railroads. Track crossings were noisy and confusing places that took the lives of workers as well as residents just traveling from point A to point B. In 1913, George Mesta built the above pictured steel bridge over the railroad tracks so that his workers did not have to risk dangerous crossings. (Borough of West Homestead.)

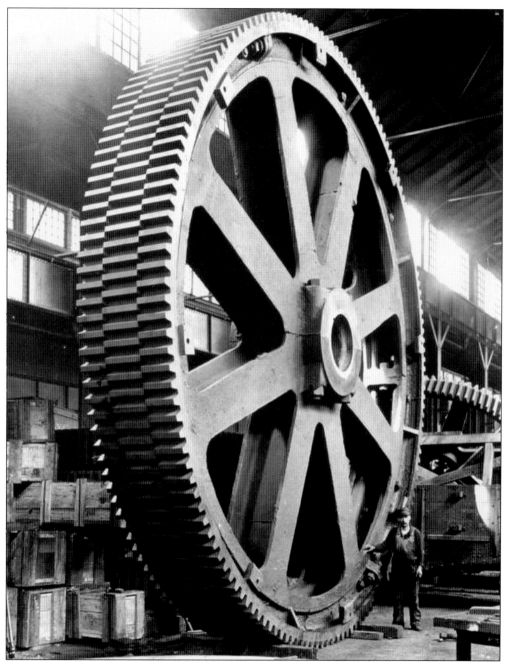

At the height of its production in the mid-1900s, Mesta Machine Company employed more than 3,000 skilled workers, machinists, and foundry workers. Their tasks were not only to manufacture the tools and machinery used by steel plants but also to create the finest specialty steel goods in the world. These goods included ship propellers, custom gears, and weapons such as a 16-inch gun used in World War II. Shown here is a molded staggered tooth gear. (Mifflin Township Historical Society.)

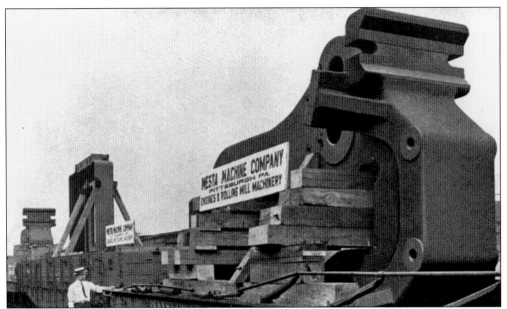

Mesta Machine Company prided itself on the fact that everything it produced was done on-site with raw materials. The only limitation posed on production was that of size and weight capacity that could be carried by the railroad. Shown here is a 180,000-pound blooming mill housing. (Carnegie Library of Homestead.)

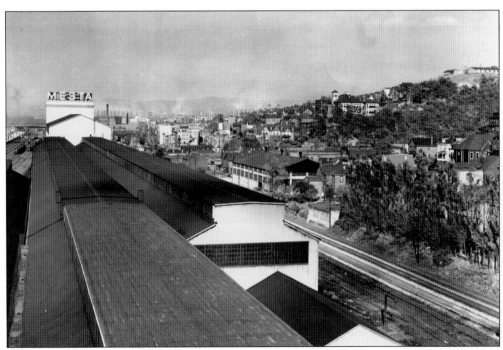

In the early 1940s, Mesta Machine Company was called upon to manufacture many of the specialty machines and parts that built the armaments used by the military. As always, the call was answered with pride and distinction. (Mifflin Township Historical Society.)

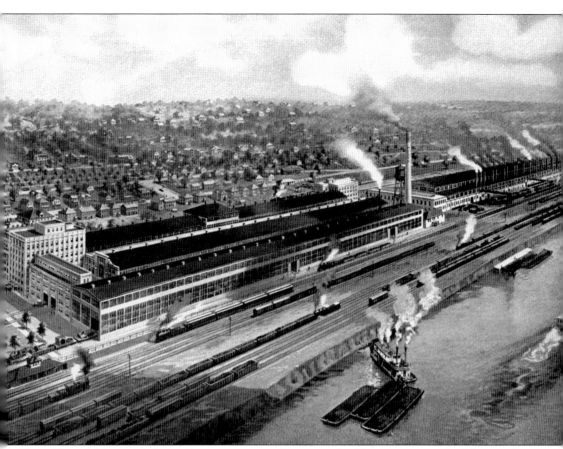

The office of Mesta Machine Company was a three-story building constructed of fireproof material. The company's general offices were located on the second floor, but perhaps the most remarkable part of the facility was the library located on the first floor. It was well stocked with engineering and technical manuals, blueprints, and scientific periodicals. What made this library unique was that it was a branch of the Carnegie Library of Homestead and accessible to all the workers and their families. (Mifflin Township Historical Society.)

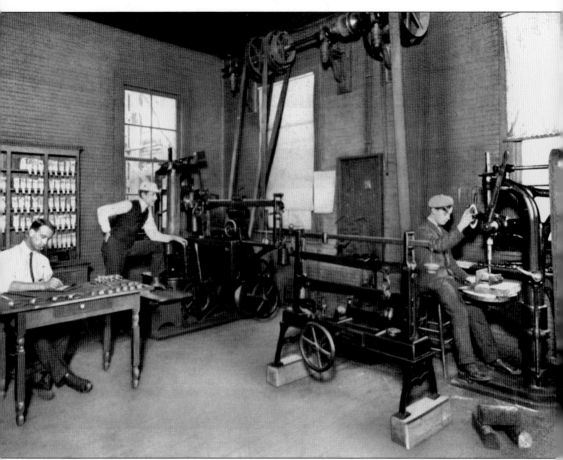

The works of Mesta Machine Company were divided into various departments and shops. The primary department was the pattern shop. It was here that the many ideas that were presented went from paper drawings to full-sized wood mock-ups to the iron and steel machines. It was imperative that these patterns be kept dry and at a constant temperature, so they were stored in specially constructed concrete buildings. (Mifflin Township Historical Society.)

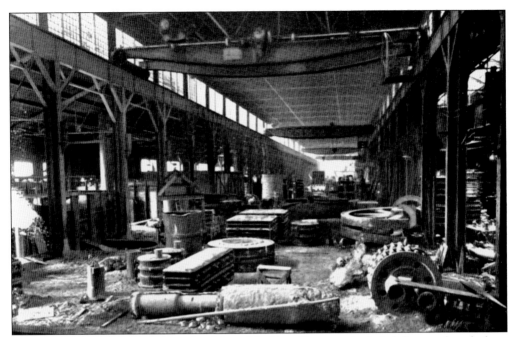

The other various departments within Mesta Machine Company included the metal yard where raw material was stored, the roll, gear, and steel foundries, and the machine shop where many of the specialty tools were produced. (Mifflin Township Historical Society.)

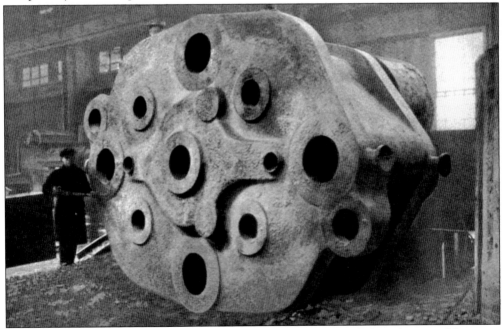

Mesta Machine Company also produced many types of engines, including those used for power plants, hoisting, reversing, and pumping. Perhaps the most sought after engines produced by Mesta were the blowing engines. These machines were designed for heavy duty and continuous use and met the needs of the then modern Bessemer and blast furnace plants. (Mifflin Township Historical Society.)

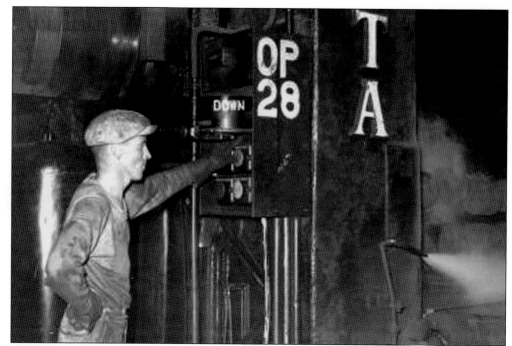

After the collapse of the steel industry in the Steel Valley, the need for the specialty steelmaking machinery diminished. In 1983, Mesta Machine Company was acquired by WHEMCO. (Carnegie Library of Pittsburgh.)

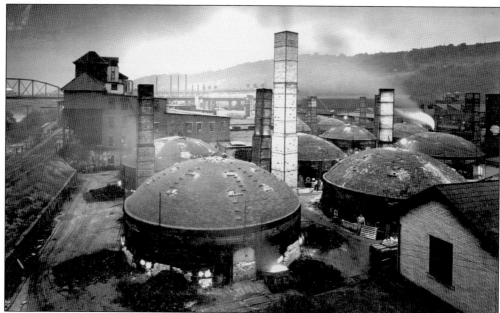

The Harbison-Walker Refractory Company, now a multinational corporation, established a research laboratory in West Homestead in 1910. The studies conducted here led to the development of super duty material used in the making of brick and fireclay that lined the walls of the kilns in the open hearth steel and other industrial furnaces. (Carnegie Library of Homestead.)

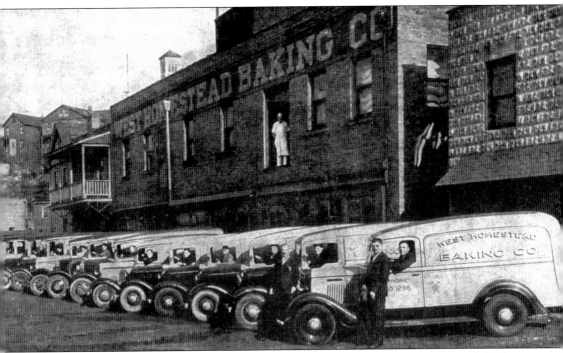

Once upon a time, the smell of fresh baked bread filled the air around West Homestead. In the days before large bakeries used robotic machines to produce thousands of loaves a day, the West Homestead Baking Company specialized in the baking of sourdough round bread at a quarter a loaf. Whether delivered to the corner store or a home, thanks to these guys, it was always delivered fresh. (Bulgarian Macedonian National Educational and Cultural Center.)

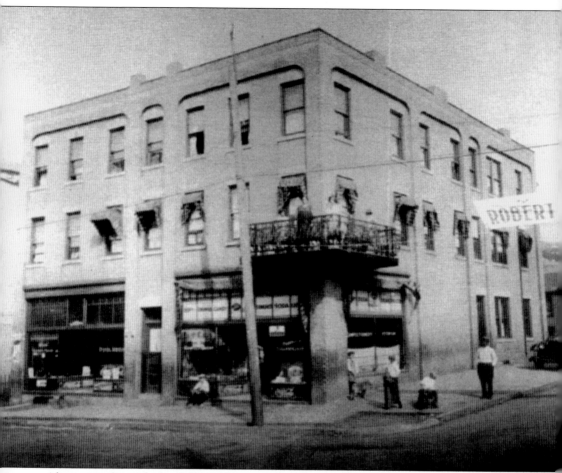

Always popular with the Calhoun Junior High School students, Estoks was on the bottom floor of the Markoff building. Located at the corner of West Eighth and Forrest Avenues, Estoks, along with the pool hall, was the favorite destination for many in the community. Lambe Markoff and his wife, Nevena, pictured in the photograph, were Yugoslavian immigrants who came to settle in West Homestead in 1905. Now at West Eighth Avenue and Forrest Avenue is the West Homestead Municipal and Community Center. (Carnegie Library of Homestead.)

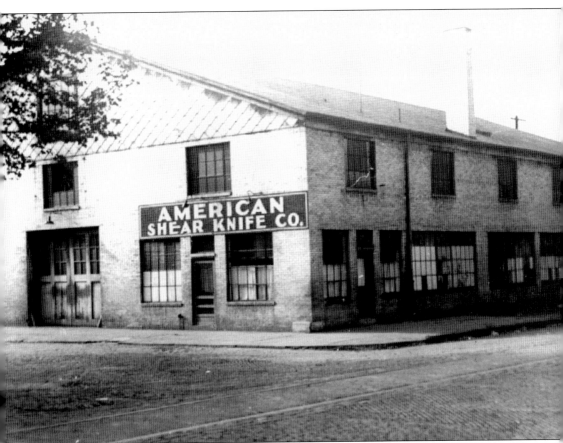

Founded in 1933, American Shear Knife Company (ASKO) is similar to many large companies that started in the Steel Valley and are successful to this day. Located on Seventh Avenue in West Homestead, ASKO serviced the needs of local and national manufacturers such as Carnegie Steel Company, Mesta Machine Company, and United States Steel Corporation by providing metal cutting, processing, and recycling services. (Carnegie Library of Homestead.)

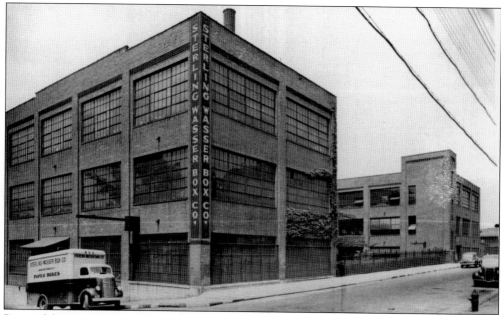

Pictured here is Sterling-Wasser Box Company. Now Keystone Plumbing, originally Wasser Box was located in Pittsburgh and was the area's largest producer of cigar boxes and hatboxes. In 1927, Wasser Box merged with the Sterling Paper Company and moved its operation to West Homestead where production expanded to feed packaging and apparel. Now part of the Ruskin Group, the company is a national leader in producing packaging and shipping products. (Carnegie Library of Homestead.)

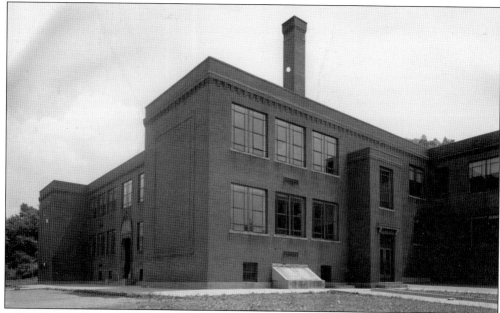

After the initial construction of Calhoun Junior High School in 1927, an annex was added in 1939 to accommodate more classroom space. The expanded building also provided for indoor recreation and sports activities. The school is seen here in the early 1940s. (Carnegie Library of Homestead.)

The Floradora Hotel, as seen in 1924, was a popular destination for traveling businessmen in need of lodging. The hotel boasted "finely appointed rooms and deluxe service." The views of the mill and railroad were surely an unadvertised bonus. (Borough of West Homestead.)

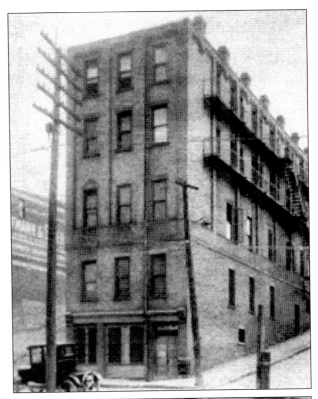

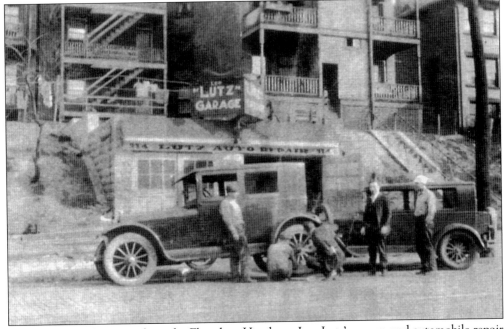

Directly across the street from the Floradora Hotel was Leo Lutz's garage and automobile repair shop. Lutz was well known throughout the Steel Valley for providing honest work to all his customers. With the exception of Lutz, there were apparently untrustworthy mechanics as far back as the 1920s. (Borough of West Homestead.)

In 1901, West Homestead Council set the wages for borough employees. They included the street commissioner to be paid $3 per day, additional street labor set at $1.75 per day, and police patrolman wages set at $50 per month, about $3 less than a laborer. (Borough of West Homestead.)

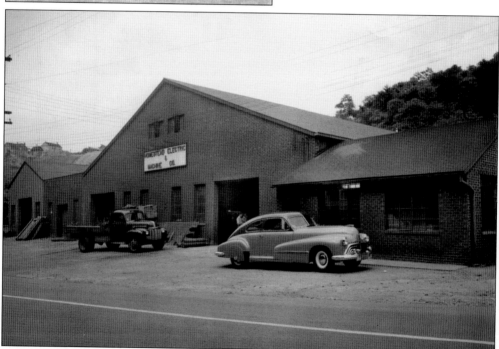

Pictured here in the late 1940s is Homestead Electric and Machine Company. A popular business with the local residents, the employees here had a reputation for being able to fix anything. (Carnegie Library of Homestead.)

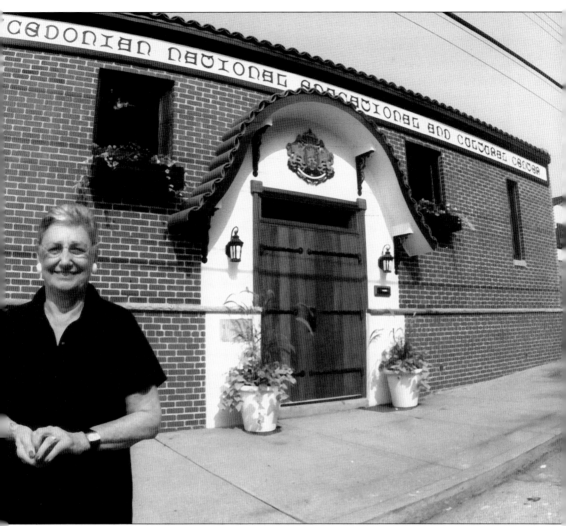

The Bulgarian Macedonian National Educational and Cultural Center is located on West Eighth Avenue. Initially structured as a social, cultural, and beneficial organization for immigrants and their families, the association soon outgrew its original accommodations, generating the need to build the new facility. Constructed in 1935, nearly right across the street from its original meeting place in the Markoff building, the new structure could better serve the nearly 550 Bulgarian Macedonian families in the area. Today the center is the oldest Bulgarian organization of its kind in the United States and is dedicated not only to preserving the rich heritage of the Bulgarian Macedonian culture but also to remaining a viable part of the West Homestead community. (Bulgarian Macedonian National Educational and Cultural Center.)

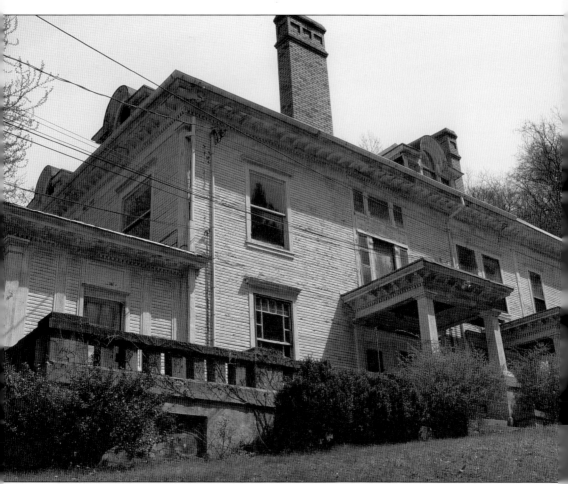

Located on West Homestead's Doyle Avenue is a grand house known as the Bryce-Mesta Mansion. Built around 1880, the house was purchased by George Mesta shortly after marrying his wife, Perle. Mesta was a self-made millionaire who, after studying engineering at the University of Pittsburgh, established Mesta Machine Company. After his death in 1925, his wife, Perle, moved to Washington, D.C., where she established herself as that city's most well-known socialite and hostess of her time. She served as the U.S. ambassador to Luxembourg from 1949 to 1953, and her activities in the nation's capital won her much acclaim and even inspired a musical written by Irving Berlin. (Daniel J. Burns.)

Six
LIFE IN THE VALLEY

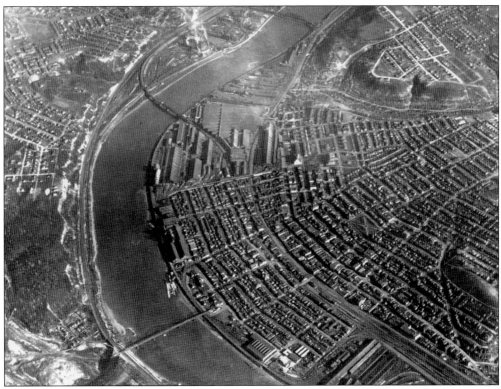

There are few people, if any, who do not recall growing up in the Steel Valley with fondness and affection. Whether they were raised in the Homestead Park area of Munhall, in a neighborhood below the tracks that was razed for the mill expansion, or in an apartment above the old Markoff building in West Homestead, everyone will say that the community was a safe and wonderful place to grow, play, marry, and raise a family. Although many people have moved on to other cities and towns, those who stayed did so without regret, not having it any other way. (Carnegie Library of Homestead.)

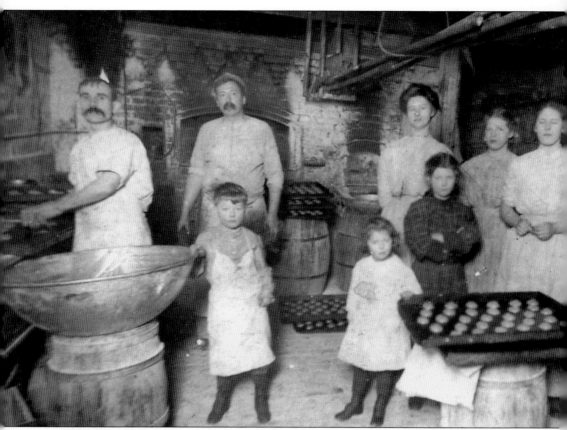

Not only were many businesses started in the Homestead area, but entire families also began new generations here in the Steel Valley. Bringing with them the customs, traditions, and recipes of their countries, many risked it all to come to America and make a better life for their children. Often these people worked as families, where parents, children, grandparents, aunts, and uncles labored long hours. (Thomas Whanger.)

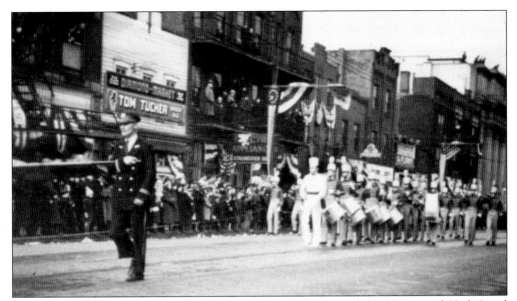

A great parade was attended by thousands for the dedication of the Homestead High Level Bridge. Dedicated in November 1937, the bridge was completed only two years after construction began. Made of massive steel girders and concrete piers, the new bridge soon gained national recognition as "one of the best bridges in America." The bridge was placed on the national historic registry 50 years after its opening. In 2002, it was renamed the Homestead Grays Bridge in honor of the Homestead Grays baseball team. (Carnegie Library of Homestead.)

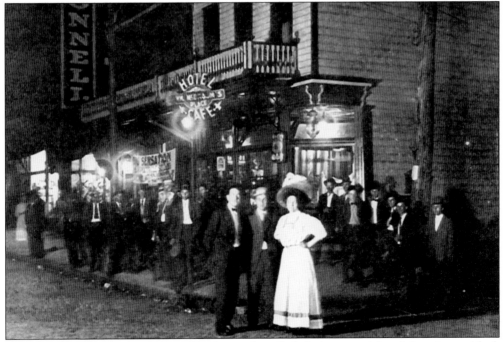

In the early 1900s, there were over 50 saloons along Eighth Avenue, eight of them in one block next to the mill gate. One has to wonder how many payroll checks were turned to liquid on payday. (Carnegie Library of Homestead.)

As the population of Homestead expanded with the influx of immigrants, the borough found itself dealing with the problem of providing education for the children of the town. Until more schools were opened to deal with the rising numbers of children, one school's ratio of students to teachers reached 64 to 1. (Carnegie Library of Homestead.)

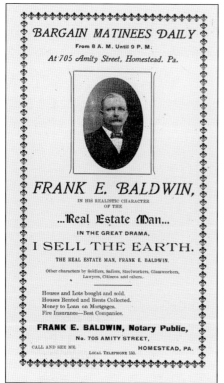

At the beginning of the 20th century, one of the most lucrative businesses to engage in was real estate. With the great influx of people to the area came the need to house them. Here in an advertisement in the local newspaper, a salesman gets creative if not theatrical in his approach to selling. (Carnegie Library of Homestead.)

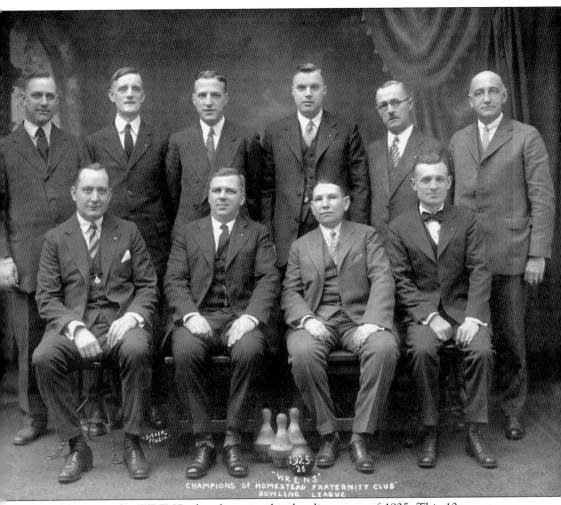

Pictured here are the WRENS, the championship bowling team of 1925. This 10-man team was one of many that participated in matches and tournaments at the Carnegie Library of Homestead. In addition to bowling against teams on an intramural basis, bowlers faced teams from other towns, including Braddock, Duquesne, and Pittsburgh. In one year alone, it was reported by the library athletic association that teams from Homestead and beyond bowled 1,838 games in the basement of the library. (Carnegie Library of Homestead.)

In addition to the workers spending their monies on alcohol, there were other ways that a man could spend his paycheck. Prior to World War II, Homestead had its own red-light district. This area posed a problem to the city fathers because the "ladies of the evening" posed a health dilemma as well as a moral one to the God-fearing residents of the town. In a time when baths were reserved for Saturday night, certain diseases became widespread to those less careful about what company they kept. (Carnegie Library of Homestead.)

As the mills expanded their production for the war effort in the 1940s and the need for manpower grew, organizations were formed to assist men in securing adequate housing for themselves and their families. (Carnegie Library of Homestead.)

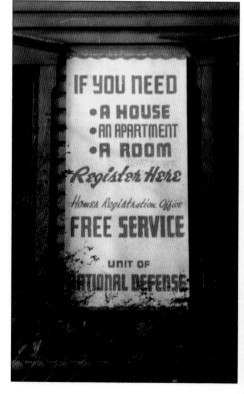

The appearance of this advertisement in the *Homestead Messenger* signaled the end of those cold Saturday night baths. Lawson's Plumbing enjoyed business success in the Mon Valley for decades. (Carnegie Library of Homestead.)

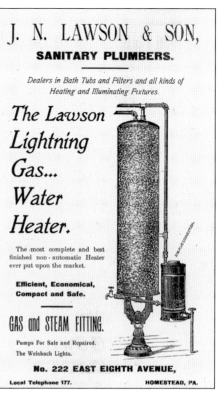

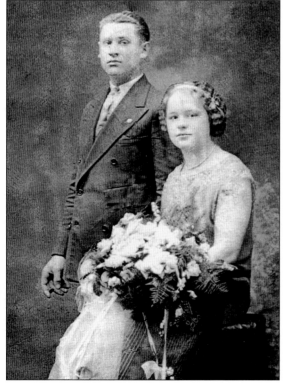

The American dream was, for most, a reality, as it is estimated that between 1920 and 1930 over 3,000 weddings took place in the Steel Valley. Pictured here are Anna and Andrew Bakaysza on their wedding day in 1927. (Jane Bodnar.)

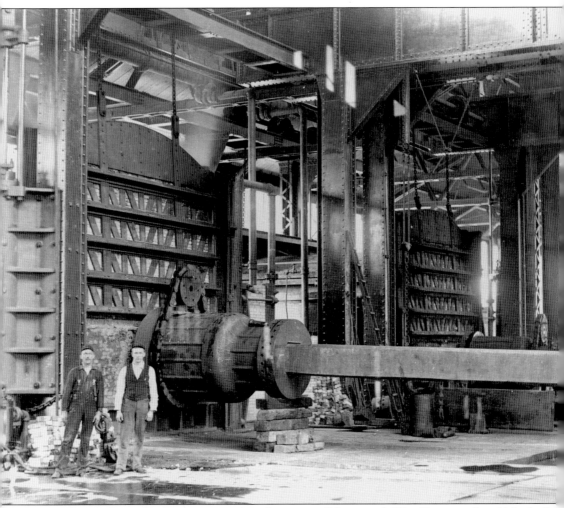

Although the steel industry gave much to the towns of Homestead, West Homestead, and Munhall over the many decades of its existence, it also took away from these communities. So that steel production could keep pace with the war effort, the government ordered an expansion of the Homestead Works in 1942. This expansion dictated the construction of 80 new buildings on over 120 acres. To accomplish this new portion of the mill, 1,200 houses, 12 churches, two convents, five schools, and countless businesses were razed. This also displaced over 8,000 residents. Although it was accepted by the community for the "good of the nation," it still hurt many to see an entire neighborhood lost forever. (Carnegie Library of Homestead.)

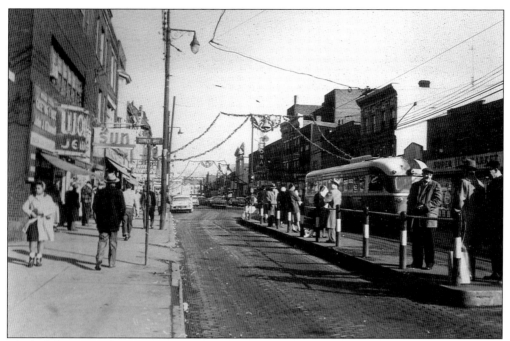

The holidays were always a special time along Eighth Avenue. The festive atmosphere could not be missed as the stores, the streets, and the people put on their holiday best. (Larry Levine.)

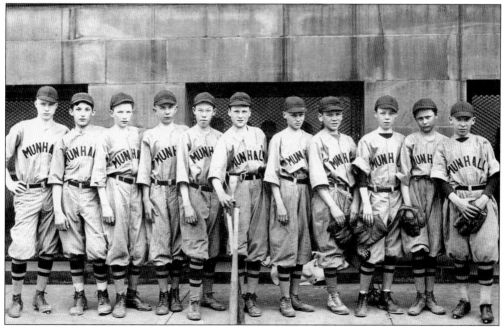

Organized sports were just as important to the youth of the Steel Valley in the early 20th century as they are today. Judging by their faces in this photograph, it is easy to see that the young men of the Munhall High School baseball team of 1919 were very serious about their game. (Carnegie Library of Homestead.)

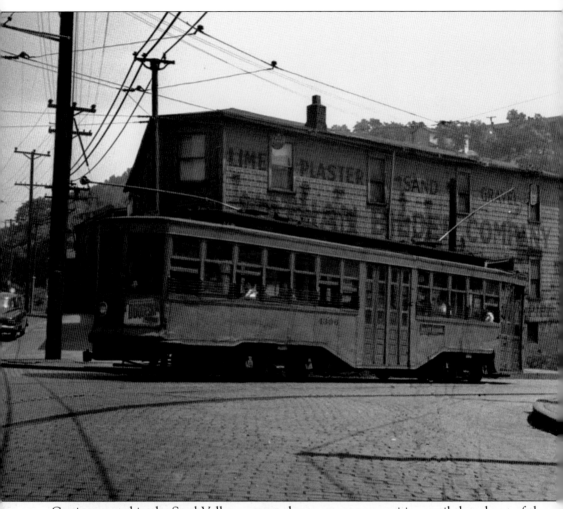

Getting around in the Steel Valley was not always an easy proposition until the advent of the streetcar. Thanks to companies like Pittsburgh Railways Company, in 1902, a man could travel from Braddock to work at any of the mills along the Monongahela River, including Homestead and Duquesne. Although a 5¢ fare made streetcars reasonably inexpensive, it was common to pick up the local newspaper and read of deaths and injuries due to faulty brakes on the local trolley. Shown here is a streetcar in front of Nathan Bilder Company on Ravine Street around 1940. (George Gula.)

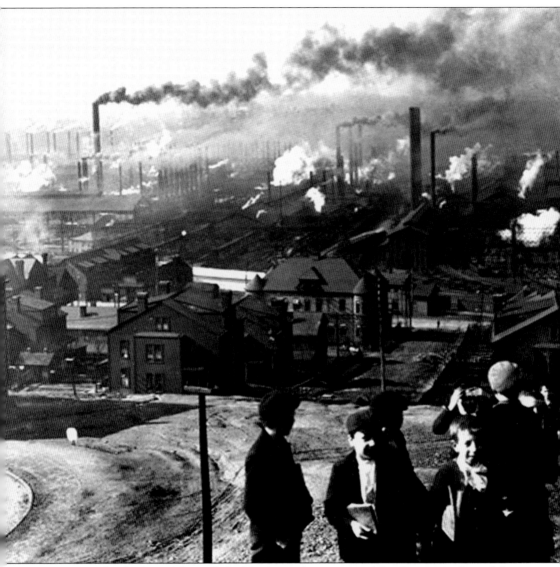

Growing up in the shadow of the mills had both its advantages and disadvantages. One of the perks was the availability of work for children of just about any age. From scavenging coal to sell for use in home and business stoves to actually working in the mill, children worked a variety of jobs in Homestead's early days. Working in the mill was just as dangerous for children as it was for adults. One report noted the death of a 15-year-old boy who was killed eight hours into his 13-hour shift. His death was accidental and attributed to carelessness due to fatigue. In the early 1900s, it was popular for boys as young as eight to begin an education in the trades. By the time they turned 18, they were earning a fair wage and had attained an important and needed skill. (Carnegie Library of Pittsburgh.)

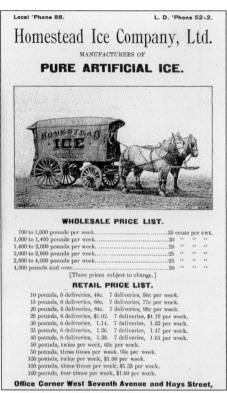

Prior to the use of household refrigeration, families had to keep their perishables cold with the help of the iceman. Delivered in quantities up to 100-pound blocks, it took a strong constitution to service the houses that sat high on the hill. (Carnegie Library of Homestead.)

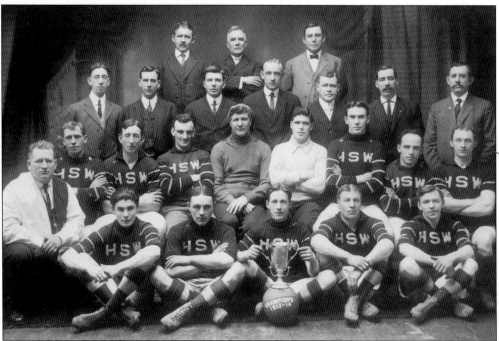

The Homestead Steel Workers Association football club had the reputation for being fearless competitors. In 1913, it was undefeated not only in the valley but also in the Greater Pittsburgh area. (Carnegie Library of Homestead.)

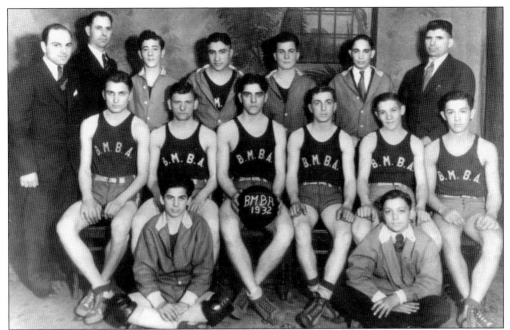

Pictured here is the 1932 Bulgarian Macedonian Beneficial Association basketball team. Like the many organized teams in the Mon Valley, the Bulgarian Macedonian Beneficial Association played many of its games at the Carnegie Library of Homestead. (Bulgarian Macedonian National Educational and Cultural Center.)

Hoffer Jewelers was located on Ann Street next to the post office. Much of its business was supported by the postal employees who shopped for their wives' and sweethearts' Valentine's, birthday, and Christmas gifts. (Carnegie Library of Homestead.)

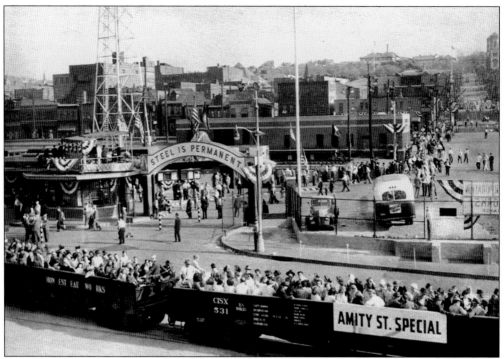

As part of the United States Steel open house celebration, the community was invited to take a tour of the mill. What a thrill it must have been to ride in a railroad coal car. (Ginny Buday.)

This 1927 photograph depicts a typical day in the Steel Valley. The smoke from the mills has blotted out the sun and everything is covered with a sootlike film. Some days it just did not pay to hang freshly washed clothing out on the line. (Carnegie Library of Homestead.)

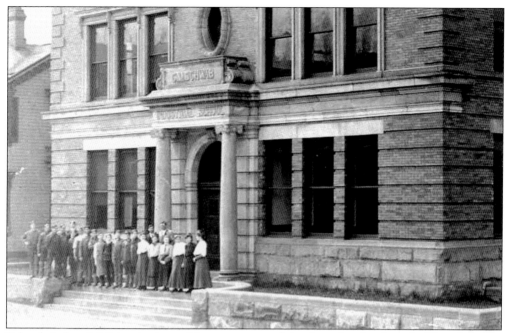

Schwab Industrial School, pictured here, was one of the first of its kind in the United States. At a construction cost of $125,000, it was Charles Schwab's idea to have a school that taught the "useful American trades" such as welding, construction, electrical work, and carpentry. (Carnegie Library of Homestead.)

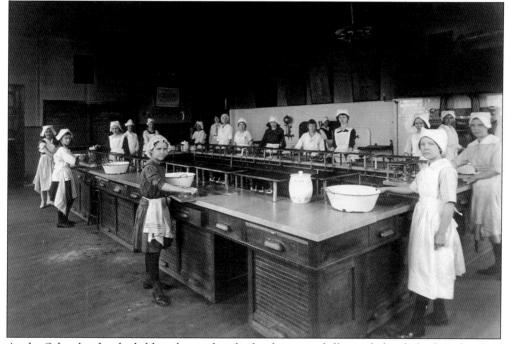

At the Schwab school, children learned early the domestic skills needed to help their families. Shown here is the sixth grade of the school where girls are learning the importance of cleanliness and sanitation. (Mifflin Township Historical Society.)

The Steel Valley is home to one of western Pennsylvania's most intriguing and highly debated mysteries. It is the disappearance of a B-25 bomber in the Monongahela River on a clear day in 1956. A little after 4:00 p.m. on January 31, an American B-25 bomber ditched in the river behind Mesta Machine Company after running out of fuel. Although the airplane sank in front of many witnesses and within minutes, the event remains Pittsburgh's most famous, if not the most interesting, mystery. Officially the bomber was never located after an exhaustive two-week search. However, there are those who believe that the airplane is still today somewhere in the river while others claim that a clandestine salvage operation was conducted to recover some secret cargo that was on board. The only part of this story that is certain is that some people know someone who saw the airplane recovered while others know someone who is sure that it is still in the water. (Daniel J. Burns.)

Seven
THE OLD MEETS THE NEW

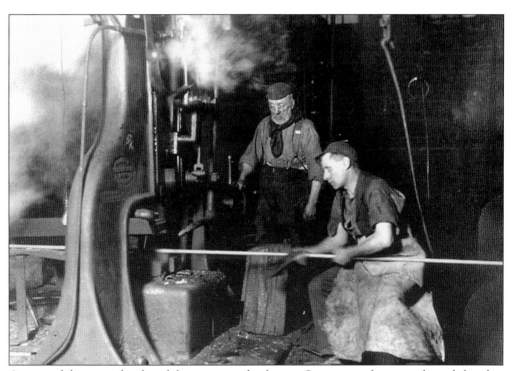

As part of the natural order of things, times do change. Sometimes change is slow while other times it comes at the blink of an eye. Although not always for the good, change will always occur as the old is replaced by the new. As these changes take place, it is easy to forget the significance of the past and how important "what was" is. The sacrifices that were made by those in the past must never be forgotten. (Carnegie Library of Homestead.)

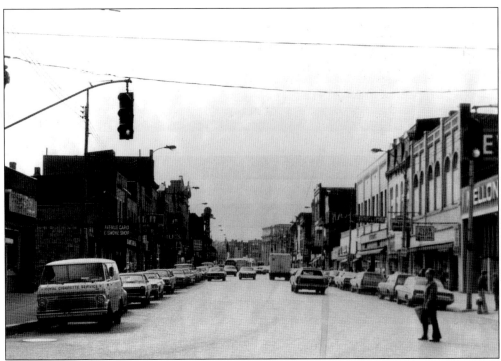

Looking west on Eighth Avenue from McClure Street, there have been a few changes to the business district here. Perhaps one of the most significant was the Leona Theater demolition. The building was such a part of the Homestead landscape, it was said a few of the construction workers were brought to tears during its demise. (Above, Carnegie Library of Homestead; below, Daniel J. Burns.)

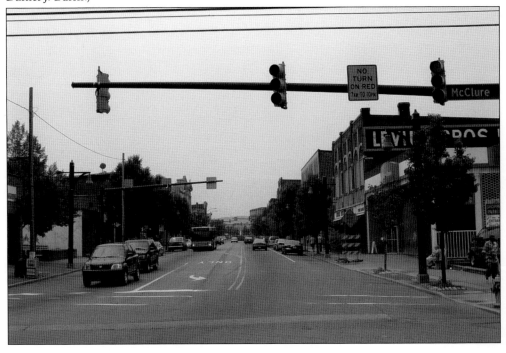

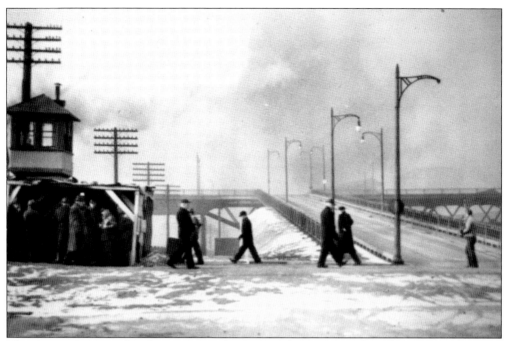

The Amity Street railroad crossing and ramp to the Homestead High Level Bridge have undergone changes over the past few years. With construction completed in 1937, the Homestead High Level Bridge was built to handle the increasing load of automobile traffic. Weighing over 8,000 tons and spanning the Monongahela River at a height of 129 feet, the span underwent a major overhaul in recent years. Deemed insufficient to handle the estimated 42,000 vehicles per day, the bridge was refurbished at a cost of over $35 million, 13 times the original cost of construction. (Above, Carnegie Library of Homestead; below, Daniel J. Burns.)

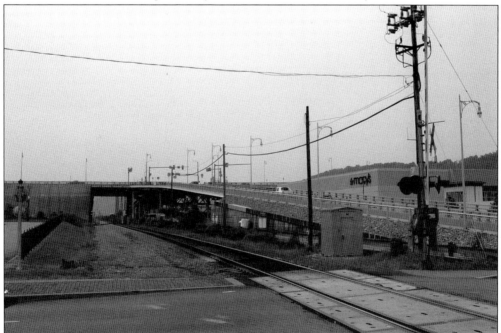

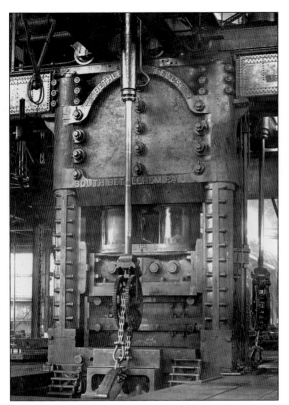

Seen here is the only known 12,000-ton hydraulic forging press left in existence. Installed in the Homestead Works in 1903, it was a viable part of the American war effort through both world wars. Many tanks and naval ships, including battleships, were outfitted with 18-inch-thick armor plating from this machine. It was said that when the 12,000-ton press squeezed billets of steel to make the armor plating, the vibration could be felt through much of Homestead. The once mighty machine that saved countless American lives now stands in the rear parking lot of a home improvement store. (Left, Mifflin Township Historical Society; below, Daniel J. Burns.)

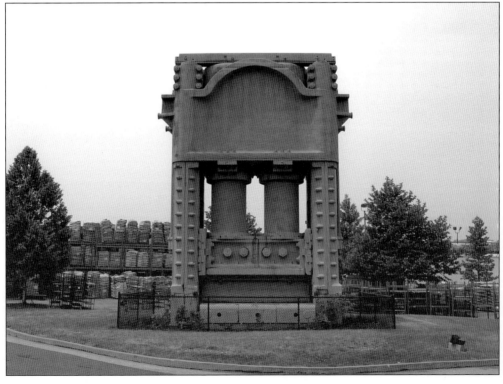

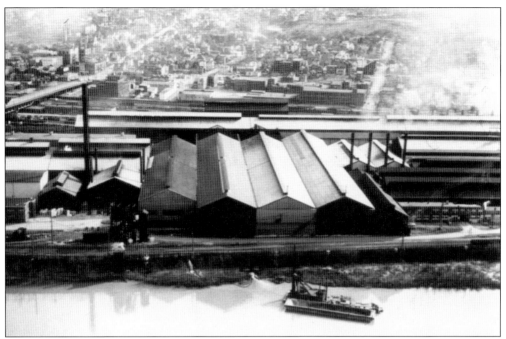

Over the 10 years between 1896 and 1906, Carnegie Steel Company experienced tremendous growth as the need for steel increased. The mill continued to expand operations, buying as much adjacent land as possible. In the early 1940s, the steel company expanded again for the war effort, but this time hundreds of residents were moved and entire neighborhoods were leveled to accommodate the mill's need for more room. With the expansion of the waterfront, the land was reclaimed for use as retail shopping and office space. (Above, Carnegie Library of Homestead; below, Daniel J. Burns.)

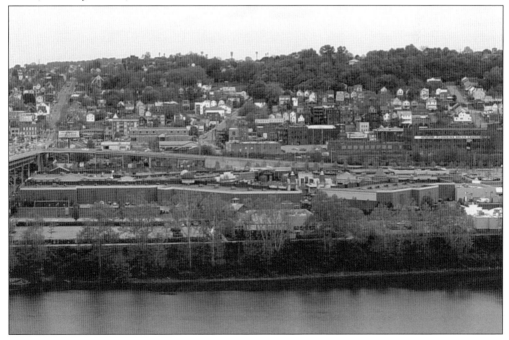

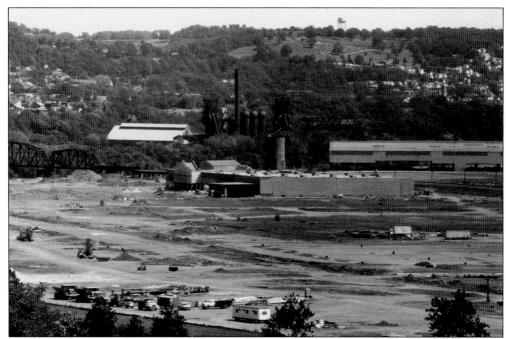

The once sprawling mill area that spanned Homestead, Munhall, and West Homestead is now a 264-acre shopping and office site. Opening in phases starting in 2001, the land reclaimed for use as retail space included 400,000 square feet of buildings in the Waterfront development's Town Center as well as scores of restaurants. Other buildings include a 217-unit apartment complex along the Monongahela River. It was said that the completion of these new businesses provided over 4,000 new jobs to the area. (Above, Ed Barrett; below, Daniel J. Burns.)

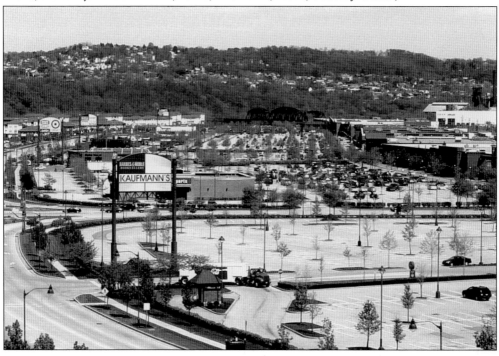

In the early 1900s, Homestead was called the "market for three boroughs and many outlying districts." It was a time when Eighth Avenue was filled with businesses that accommodated the needs of just about everyone. These businesses included banks, butcher shops, real estate offices, bakeries, furniture stores, doctors' offices, and barbershops. Although restaurants really were not popular at that time, saloons offered some food to patrons to be enjoyed with their libations. (Right, Larry Levine; below, Daniel J. Burns.)

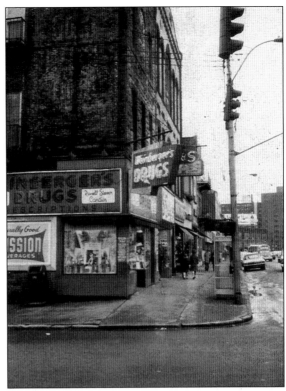

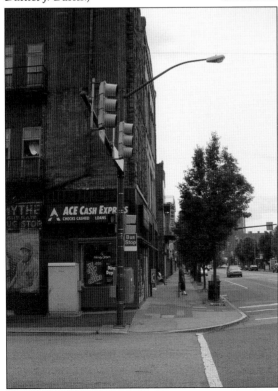

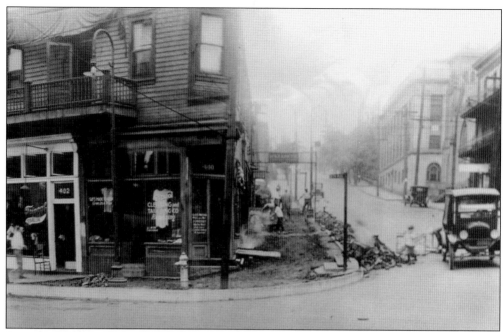

In early 1891, the Borough of Homestead began construction of a new water reservoir to accommodate the expanding town and its residents. Part of the plan to pay for this new facility was to restructure the costs of supplying water to each household. The water rates per month per house in 1892 were as follows: one to two rooms, $3; three rooms, $3.50; four rooms, $4; and so on. Added costs for each house were also structured as follows: each bathtub, $3; each sink, $1; each stationary washtub, $2; and each water closet, $3. (Above, MDL Insurance; below, Daniel J. Burns.)

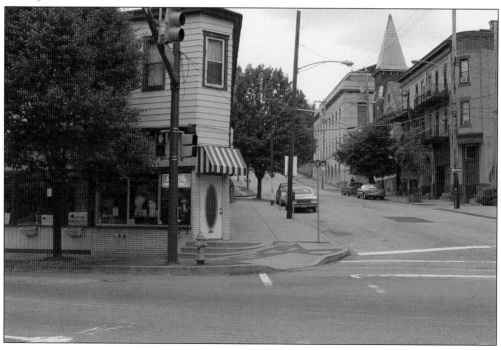

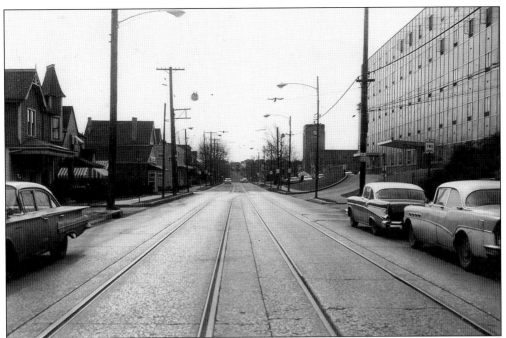

As late as 1900, there were still many dirt roads in the Steel Valley. Not until there was a need to move goods and products by vehicle was there a need for paved and improved streets. Before the streets were improved, getting around was a daunting task. When it rained, men and horses got bogged down in what one reporter called "unforgiving muck." Later methods of transportation within the communities included the streetcar, which ran past the hospital on West Street. (Above, Carnegie Library of Homestead; below, Daniel J. Burns.)

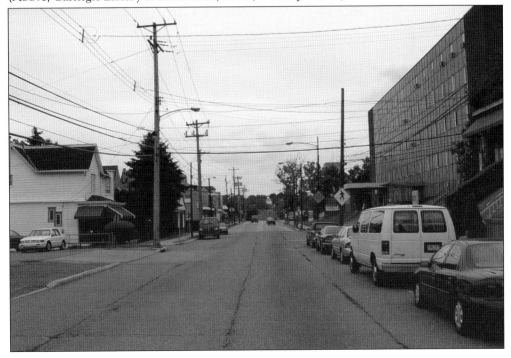

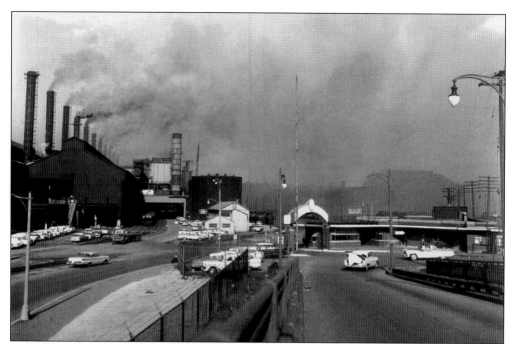

There is no argument that, in its heyday, Homestead was known throughout the world as the steelmaking capital. In the 1890s, the Homestead Works of Carnegie Steel operated on 300 acres of land with 40 of those acres under cover and inside buildings. During that time, the mill employed over 4,000 workers, both skilled and unskilled, and had a two-week average payroll of $90,000. America was expanding on Carnegie Homestead steel. (Above, Carnegie Library of Pittsburgh; below, Daniel J. Burns.)

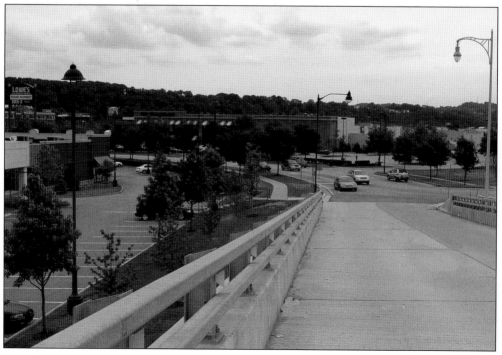

The landscape around the Carrie Furnace has changed much since the mill ceased operations in 1978. Although located across the Monongahela River in the borough of Rankin, the Carrie Furnace was a part of the Homestead Works. At the furnace's top production period in the 1950s and 1960s, the Carrie Furnace consistently produced over 1,000 tons of iron a day. Now a national historic landmark, the Carrie Furnace site will soon be a cultural and educational destination where visitors can tour the area and see how the mills of the Steel Valley shaped the rest of the world. (Right, Carnegie Library of Pittsburgh; below, Daniel J. Burns.)

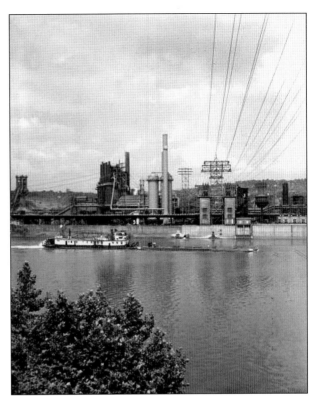

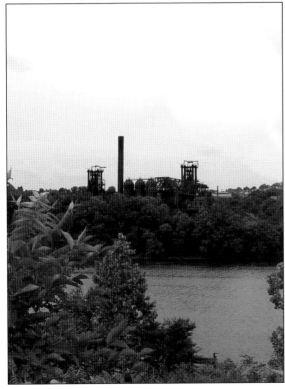

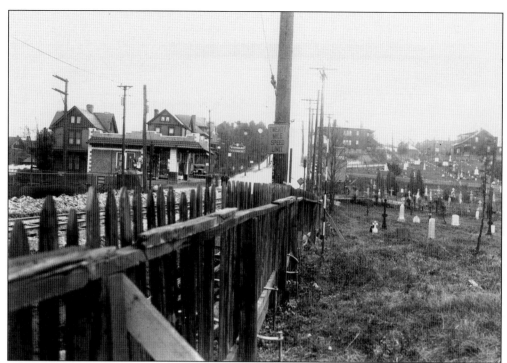

Dedicated in 1899, St. Mary's Cemetery's front entrance is guarded by statues of St. Michael the Archangel and the Good Shepherd. Much has changed since the 1920s photograph. The Standard Oil station and the streetcar tracks are gone. The old wooden fence has been removed along with the 20-mile-per-hour speed limit sign. (Above, Carnegie Library of Homestead; below, Samantha Burns.)

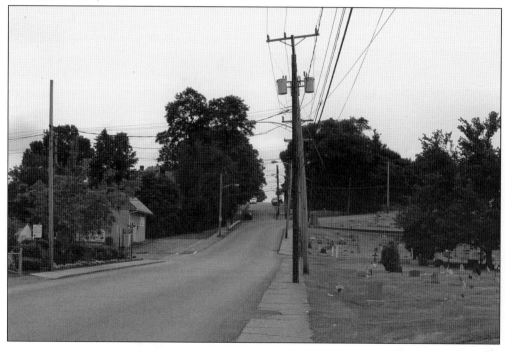

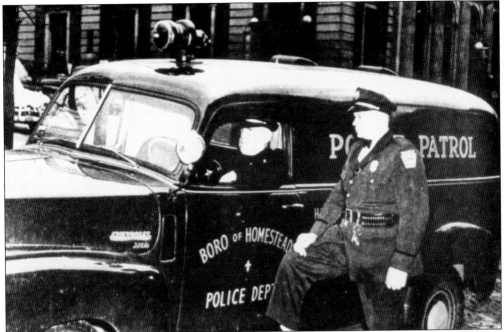

Over the past 70 years, there have been many changes for policing in the Steel Valley. In the heyday of the steel mills, it took a strong and tough cop to patrol the streets and bars of Homestead. A mill worker off his shift with his paycheck in hand did not want to hear that he had too much to drink or that it was closing time. The end result was usually a good knockdown, drag out brawl and a night in the drunk tank for the offender. (Above, Carnegie Library of Homestead; below, Daniel J. Burns.)

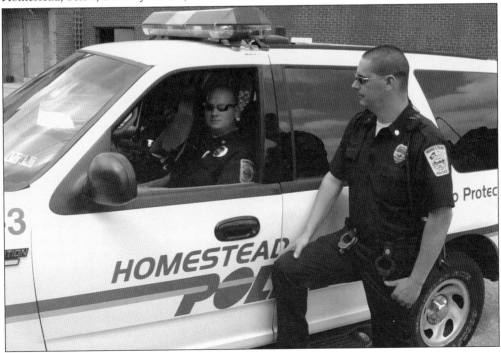

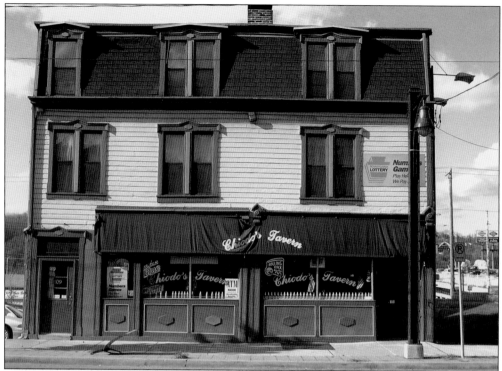

For decades, Chiodo's Tavern on Eighth Avenue was the favorite haunt for many in the community. Home of the Mystery Sandwich, Chiodo's drew people from as far away as the West Coast to sample the atmosphere, the hospitality, and the sandwich. As change often brings progress, the old building on the corner at the bridge was demolished to make way for a new drugstore and, ironically, a new sandwich shop. (Above, Gerard Thurman; below, Daniel J. Burns.)

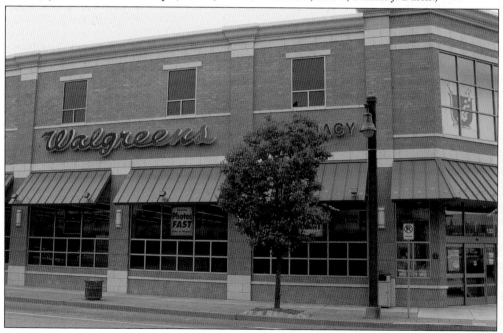

Eight
THE STEEL VALLEY RENEWED

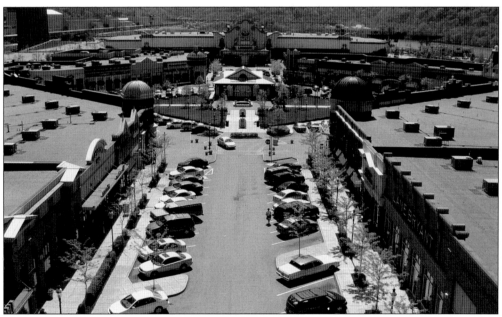

When the steelmaking industry collapsed in the 1980s, it left most people who lived in the Steel Valley wondering, "What will we do now?" Manufacturing in Homestead, West Homestead, and Munhall was not only a job but also a way of life. For generations, men and women labored in the hot mills, making the material that built, expanded, and defended the nation. These people put food on their tables and their children through college from the wages they earned at companies like Mesta Machine Company and the Homestead Works of United States Steel. When the mills closed, the American dream seemed to turn into a nightmare until a new dream was born. (Daniel J. Burns.)

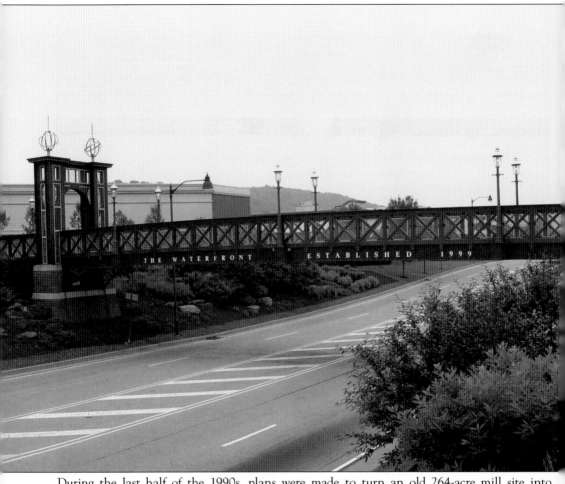

During the last half of the 1990s, plans were made to turn an old 264-acre mill site into Pittsburgh's newest shopping destination. To accomplish this task, it took dozens of construction crews and thousands of man-hours to dismantle the rusting structures and clear the land. The first phase of this project was to install a new $25 million infrastructure that would support the revitalization of the land. (Daniel J. Burns.)

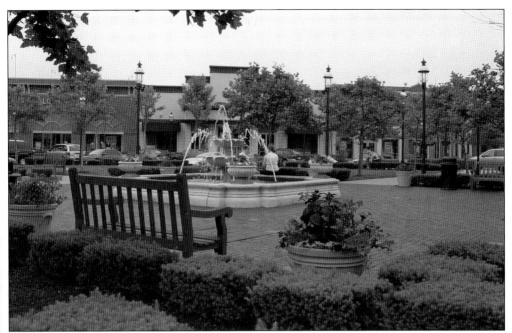

The end result of the $300 million real estate venture is a plethora of stores, restaurants, boutiques, and specialty shops that cater to all buyers. The area is never without colorful decor, including flowers in the spring and summer and festive holiday decorations in the winter. (Daniel J. Burns.)

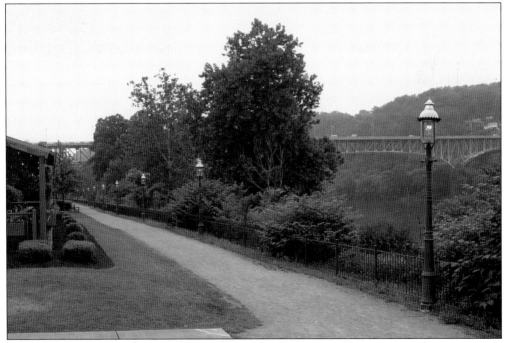

The area that was once the hub of the world's steel industry now offers a variety of entertainment options. At the Waterfront development, visitors can relax on the patio of their favorite club or restaurant, take in a movie, or just stroll along the riverside trail. (Daniel J. Burns.)

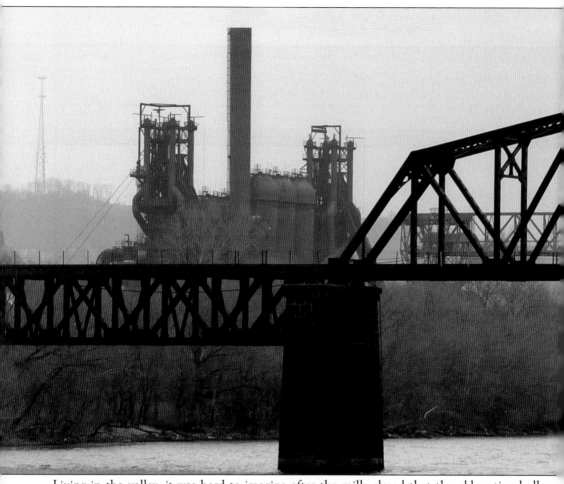

Living in the valley, it was hard to imagine after the mills closed that the old rusting hulks would be replaced by rows of stores and restaurants. To date, nowhere in the United States has development on this scale met with so much success. This success is attributed to the cooperation of the local governments, real estate investors, developers, and business leaders. A few tax deferments did not hurt either. (Daniel J. Burns.)

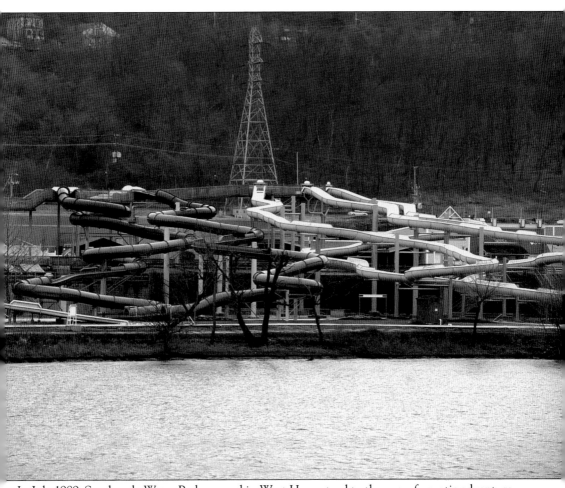

In July 1989, Sandcastle Water Park opened in West Homestead to throngs of aquatic adventure seekers. Part of Kennywood Amusement, Sandcastle guests can enjoy the excitement of a 300,000-gallon wave pool, choose from 15 different waterslides, or just take a leisurely raft trip down the in-park river. In addition to the slides and rides, visitors can also enjoy specialty shops and arcades along the boardwalk. A nightclub for guests 21 and over is yet another attraction that Sandcastle has to offer. (Daniel J. Burns.)

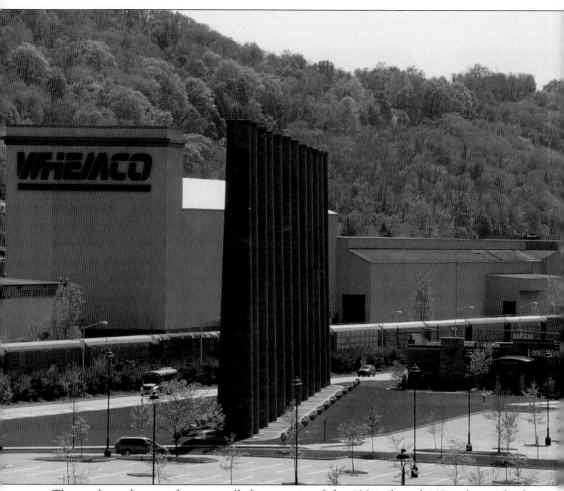

The smokestacks, seen here, are all that remain of the 100-inch and 160-inch semifinishing operation of the mill. After hot steel was poured into ingot molds, the steel was cooled and then reheated again so it could be rolled into slabs. In order for the steel to be reheated correctly and thoroughly, it was placed in underground pits. These pits were located adjacent to these 100-foot-tall smokestacks that vented the carbon dioxide and carbon monoxide gases safely into the atmosphere. (Daniel J. Burns.)

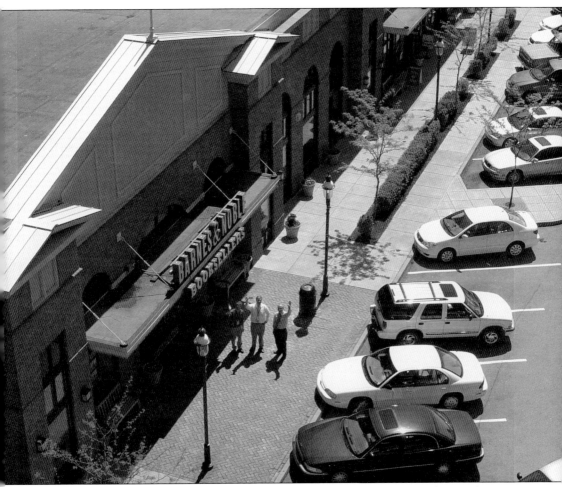

Today the stores and eateries at the Waterfront development continue to be the number-one destination for Pittsburghers to shop. It is important to remember that the success of the Waterfront is attributed not only to the developers and real estate investors but also to the wisdom and tenacity of the mayors, community leaders, and residents who never stopped believing that the end of the steel mills did not mean the end of hope. (Daniel J. Burns.)

www.arcadiapublishing.com

Discover books about the town where you grew up, the cities where your friends and families live, the town where your parents met, or even that retirement spot you've been dreaming about. Our Web site provides history lovers with exclusive deals, advanced notification about new titles, e-mail alerts of author events, and much more.

Arcadia Publishing, the leading local history publisher in the United States, is committed to making history accessible and meaningful through publishing books that celebrate and preserve the heritage of America's people and places. Consistent with our mission to preserve history on a local level, this book was printed in South Carolina on American-made paper and manufactured entirely in the United States.

This book carries the accredited Forest Stewardship Council (FSC) label and is printed on 100 percent FSC-certified paper. Products carrying the FSC label are independently certified to assure consumers that they come from forests that are managed to meet the social, economic, and ecological needs of present and future generations.

Mixed Sources
Product group from well-managed forests and other controlled sources

Cert no. SW-COC-001530
www.fsc.org
© 1996 Forest Stewardship Council

Find Your Place in History.